IMAGES
of America
POWAY

D1255141

ON THE COVER: Early white settlers of the Poway Valley tended to come to the area as a family unit rather than as individual adventurers or fortune seekers, although there were some of those as well.

IMAGES
of America

POWAY

Jeff Figler

ARCADIA
PUBLISHING

Copyright © 2007 by Jeff Figler
ISBN 978-0-7385-5597-3

Published by Arcadia Publishing
Charleston, South Carolina

Printed in the United States of America

Library of Congress Catalog Card Number: 2007927479

For all general information contact Arcadia Publishing at:
Telephone 843-853-2070
Fax 843-853-0044
E-mail sales@arcadiapublishing.com
For customer service and orders:
Toll-Free 1-888-313-2665

Visit us on the Internet at www.arcadiapublishing.com

A book on Poway's rich history would not have been possible without
the spirit and determination of every generation of Powegian that
has come before us. To the devoted farmers and ranchers who
worked the land, to the adventurers who sought gold, and to the
big thinkers who transformed a quiet rural community into the
bustling city it is today, we say thank you. This book is for you.

CONTENTS

ACKNOWLEDGMENTS

All photographs in this book were provided by the Poway Historical Society unless otherwise noted. The Poway Chamber of Commerce and the *Poway News Chieftain* were also generous contributors. As recorders of Poway's past, present, and future, each is a jewel within the jewel that we fondly call Poway. A special thank you goes to Jessica Long for her invaluable assistance. Thanks also go to Paolo Romero of the City of Poway for his guidance and direction; Sandra Sauceda; Catherine Cordova of the Jefferson Corporation for the office and clerical support; and to my wife, Linda, whose help toward the completion of this book is greatly appreciated.

INTRODUCTION

Today Poway is a thriving city of 50,000 residents and an extra-large workforce contributing to a robust local economy—a stark contrast from its more well-known urbanite neighbor to the south, San Diego. Perhaps that is why this self-proclaimed "City in the Country" attracts some of San Diego's biggest names even without the flashy name recognition of San Diego proper or the beachfront views of the county's more affluent areas. Some of the most-beloved players in Major League Baseball and the National Football League call Poway home, not to mention esteemed surgeons and powerful corporate executives, begging these questions: What makes the city so special, and how did it get here?

For starters, its streets are well paved and primly landscaped. The public schools are distinguished as being among California's best. And 25,000 acres of open space ideal for hikes and other outings beckon fond memories of simpler times long past. Indeed, Poway's steady, well-rounded approach to living makes it one of the "wealthiest" communities in San Diego County. It is hard to believe that less than 30 years ago, Poway was not even a city. It was instead a rural community on the brink of city-hood, a place someone once described as an area forgotten about by county planning officials for far too long.

City-hood for Poway all began in the late 1950s when the first single-family home subdivision was built in the area and the proponents of progress helped establish a more permanent water source: Lake Poway. All this progress came to fruition in December 1980 when Poway incorporated as a city. The name *Poway* is reflective of the city's original landscape and its original residents, although it is not necessarily the location's original name. Several hundred years ago, before the Spaniards came, Poway, like much of San Diego County, was inhabited by the Kumeyaay and Luiseno Indians. Records of the time show that the area was known by several similar names, including Paguay, one of the more frequently referenced. According to old San Diego Courthouse records, "Paui" appeared in 1855, "Pauay" in 1861, "Pouai" in 1866, "Pauhuae" in 1867, "Pauai" in 1868 and 1869, and Paguay in 1869. Popular speculation suggests that a simple spelling error on the part of a U.S. postmaster general gave the city its current "Poway" in 1870.

By then, Poway had become a popular destination for settlers and California gold seekers who started showing up in the mid-1800s. It was a rocky start at first. An extended period of drought conditions for the entire county made it tough for would-be farmers and ranchers to survive; therefore, many left almost as quickly as they had arrived. When the drought conditions lifted in the late 1870s and early 1880s, the area began to boom once more. Original settlers took advantage of the influx and sold off portions of their vast homesteads to newcomers for anywhere from $20 to $40 an acre, according to old land records.

The first known white settler in Poway is thought to be Philip Crosthwaite, who arrived in 1859 and took up ranching. Crosthwaite was a volunteer soldier in the Mexican-American War and fought in the Battle of San Pasqual just outside Escondido on December 6, 1846. He emigrated from Ireland by way of ship and arrived in San Diego the same year he fought in the Battle of San Pasqual. Crosthwaite filed a claim for 160 acres in the Poway Valley in 1855, five years after

California became a state, thanks in part to the favorable outcome of the Mexican-American War. He built an adobe house, whose ruins remained for years for future generations to see. Today the house's former site is located near the Creekside Plaza, a shopping center toward the city's eastern edge.

By 1869, another rancher by the name of Castanos Paine had asked the federal government to open a post office in Poway. The opening marked the only known post office between San Diego and San Bernardino at the time. Mail arrived twice a day by stagecoach. One stagecoach came from the south, the other the north. And by 1887, the general area in and around Poway had expanded to roughly 800 men, women, and children—the original modern-day Powegian families.

The stagecoach industry soon gave way to train technology, and big plans were made as a British developer moved in in anticipation of the railroad line that would connect Poway with San Diego and other areas to the north. A real estate boom occurred in Poway in the late 1880s to 1900 because of it. As a result, many of the city's streets are derived from British names, including Midland Road and York and Aubrey Streets. An article in the early newsletter *Poway Progress* exemplified the impending excitement of the railroad's arrival. It read as follows:

> Let everyone pledge himself to do something toward the undertaking which will build up and advance prosperity of Poway as nothing else would. Now is our opportunity to help ourselves into better conditions; and remember, you are not asked to part with a dollar or an acre until the road is completed and cars are running. This is certainly a favorable and fair proposition, for with trains of cars running by outdoors, values will double and triple at once, and we shall wake up to a new life.

But the line never came. Poway's geography and mountainous landscape were not conducive to building railroad tracks. Sadly, three months later, the *Poway Progress* read simply, "Nothing further will probably be done in the matter."

The end of railroad dreams put a dramatic halt to the area's growth, and by the dawn of the 20th century, Poway's population had peaked temporarily at about 1,000. Throughout the early 1900s, Poway's image was one of a mainly agricultural area. Most of the residents were farmers with peaches, grapes, grain, and alfalfa being the major products. By the middle of the 20th century, times were pretty quiet. The population grew steadily but slowly; however, not all roads were blocked with the loss of the railroad.

The Federal Aid Highway Act of 1925 created Highway 395. Known today as Pomerado Road, Highway 395 began its existence as a major north-south roadway that wound through Poway to downtown San Diego. To the north, it was said to take a traveler all the way to the Canadian border, just north of Laurier, Washington. The act that made Highway 395 possible was itself a lesson in progress. It sought to eliminate the confusion regarding older highways named after people and places by assigning numbers instead. The number 395 was eventually retired in California because Interstate 15 was built pretty much parallel to Poway's portion of 395 in the 1970s. But before that could happen, Poway steadily grew due to its major thoroughfare.

Eventually, by the 1950s, subdivisions entered the picture, and social activities abounded in Poway again. It was then that a community newspaper was created.

At the time, the Poway Chamber of Commerce, which was created to be a men's social club, ran the newspaper. News focused on such things as comings and goings, births and deaths, and what sorts of specials the local market was running. In 1955, the same year the newspaper began, the next major movement toward city-hood occurred with the addition of Poway's first water storage tank. The introduction of a permanent water supply and the Poway Municipal Water District paved the way for new residents. From there, Poway grew quickly. And by December 1980, all the pieces were in place to incorporate the area as the "City in the Country."

In the nearly 30 years that Poway has been a city, it has grown and adapted to all sorts of modern conveniences and commerce. But let it never be said that Powegians have forgotten their roots. Old-fashioned celebrations are regular occurrences today, and schoolchildren look no farther than Old Poway Park and its adjacent historical museum for glimpses into the past. The Poway-Midland Railroad Volunteers formed in the earlier years of Poway becoming a city in order to build and

maintain a fun and educational railroad. The group operates out of Old Poway Park with a short-line track similar to the one envisioned for Poway more than a century ago. More than a quarter of a million Poway residents and visitors have since taken a ride on the track.

Poway houses a district that runs 23 elementary schools, 6 middle schools, 4 comprehensive high schools, and 1 continuation high school, all within a 100-square-mile area. Some two dozen Poway Unified School District schools are California Distinguished Schools, while another dozen or so are National Blue Ribbon Schools.

Not all schools are in Poway, as some serve San Diego's northernmost suburbs that are situated around the Poway city limits. The city of Poway makes up only about 40 square miles of the 100-square-mile area served by the Poway Unified School District. In the city, the district runs 8 of its 23 elementary schools, 2 of its 6 middle schools, 1 of its 4 comprehensive high schools, and its only continuation high school for students who need an alternative to the traditional high school setting. The district is also the biggest employer in Poway, followed by a number of large companies located in the business park and the city itself.

A city manager, a city attorney, a city clerk, and six department heads, who oversee everything from safety to redevelopment services, run Poway. Major decisions are made by the Poway City Council, which consists of a mayor, deputy mayor, and three council members. The 13th-largest incorporated city in San Diego County, Poway works with an annual general fund budget of about $67 million. Around 250 full-time and 85 part-time workers are employed by the city.

Another major employer is the 107-bed, acute-care Pomerado Hospital. Pomerado is part of Palomar Pomerado Health, a nonprofit system that also runs another hospital in Escondido called Palomar Medical Center. As part of the largest public health district in California, Pomerado employs 750 people. It also maintains a healthy volunteer auxiliary, primarily featuring retired seniors and teenagers looking to do some community service or explore interests in a health care career after high school. Indeed, Poway is a healthy city today but one that has begun to reach maturity. During the course of the next decade or so, Poway will reach full build-out and look to new ways to handle itself. Well-laid redevelopment plans have already been put in motion, including visions of bigger and better projects incorporating both modern architecture and state-of-the-art features with a respect for the past.

One

EARLY BEGINNINGS

Although both the white settlers and Spaniards can plot the days they "discovered" Poway, the valley rich with fruitful soil and multiple river streams was already home to a population of people long before anyone could have imagined. Like much of North America, the area known as Poway was inhabited by an indigenous group. The Kumeyaay-Ipais were a group of Native Americans who populated much of San Diego County. Also like much of North America, the way of living created by the Kumeyaay-Ipai tribe was eventually moved aside by the white settlers and Spaniards, leading to the beginning of what would become the city of Poway.

The first white settlers to the valley of Poway came in the mid-1800s, following the outcome of the Mexican-American War. Development of the valley stopped almost as quickly as it started when major drought conditions struck the region. These conditions soon faded and development resumed in the first of several starts and stops for the valley, which was named for the multiple creek beds that happen to meet there. The convenience of this natural resource may have been what drew the very first Powegians—the Kumeyaay-Ipais—to the valley in the first place.

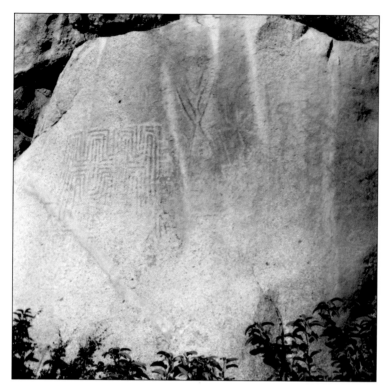

Archaeologists researching pictographs and other evidence believe Native Americans roamed the Poway area as early as 900 years ago. The Kumeyaay Indians, in particular, are believed to have given Poway its name. Pictographs, or rock paintings, can still be found today in North Poway.

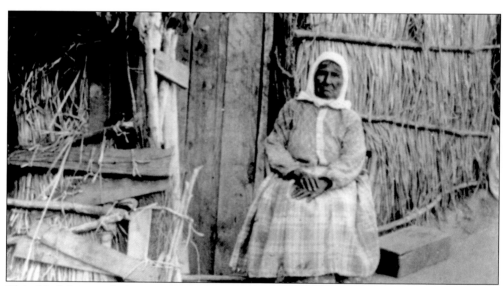

This elderly Liuseno Indian woman, seen in 1893, no doubt adopted her clothing habits from the influx of white settlers to the region. Poway's earliest residents, both men and women, originally wore clothing made from bark strips and went barefoot most of the time. When they felt a chill, they would don robes made of woven rabbit skins.

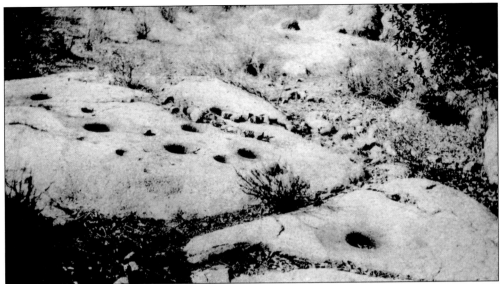

Acorns found in native oak trees were the main staple of Native Americans in the Poway area. Meal and mush was made from grinding them on what is known as a metate, an indentation in a rock or stone brought about by constant grinding movement. The acorn meal and mush was then flavored using berries and/or meat such as rabbit, deer, and squirrel.

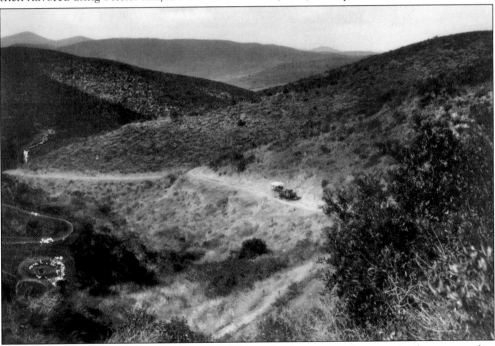

In the late 1800s, the south end of the original Poway Grade was a vital entry point for stagecoaches as white settlers began to populate. Rancher Castonas Paine is said to have come to Poway in 1868 to establish the very first stagecoach stop between San Diego and Escondido. He asked for a post office to be established at Paine's Ranch but was denied naming rights when the U.S. postmaster general chose "Poway" instead. Popular belief is that the postmaster misspelled Paguay, the name given to the area by the Kumeyaay Indians.

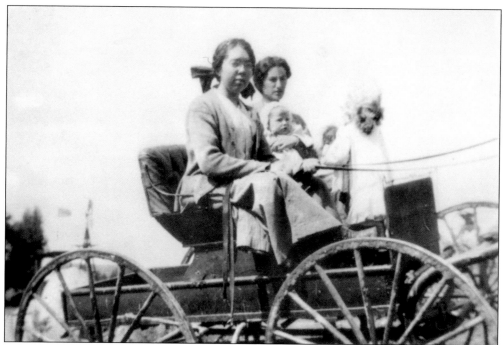

When the Poway Post Office opened on June 2, 1870, settlers could not expect home delivery. Instead, they rode a horse-and-buggy across bumpy dirt roads to the building. In the roughness of a settling area, the stereotypical roles of men and women common on the East Coast did not always apply; however, women reared children and carpooled much like today.

The Stokes Adobe House, one of Poway's earliest homes, played host to Gen. Stephen Watts Kearny and his staff the night before the Battle of San Pasqual in December 1846. During the Mexican-American War, Kearny led 139 men into battle against Mexico's 150. Of Kearny's men, 22 were killed, 18 wounded, and 1 missing compared to the 11 killed or wounded on the Mexican side. Kearny still claimed victory; of course, so did the Mexicans.

Dr. Louis N. Hilleary, Poway's first physician, practiced medicine locally after arriving from Iowa in 1881. Among the wealthiest residents, he later donated funds for the Community Church and land for Poway's first cemetery, later named Dearborn Memorial Park. Today a street in Poway memorializes Dr. Hilleary. A community park full of sports fields and playground equipment also carries his name.

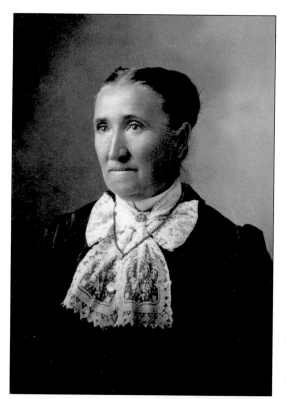

The Kirkham family traveled from Colorado to Poway in 1891. Mr. Kirkham, already in poor health when he arrived, died in 1903, leaving his wife at the family's helm. She went on to homestead 160 acres with the help of her four sons. Today a street in Poway's business park is named for the family.

Early Poway settler John T. Dearborn was the first to be buried in the town's cemetery, Dearborn Memorial Park, giving it its name. Located along Twin Peaks Road, the cemetery originally consisted of 96 blocks, each containing 32 grave sites. The blocks sold for $20 each.

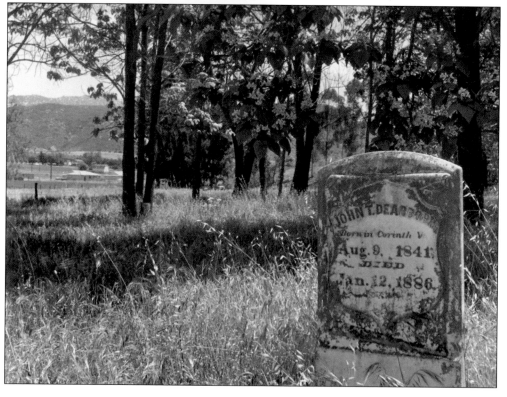

The Poway Post Office was run by postmistress Annie E. Smith in 1894. Visitors who would stop to chat included schoolteacher Edward Warren. Until 1889, Poway provided the only post office in the valley. That year, the Stowe Post Office started serving settlers in the southeastern part of the valley; in 1900, the Bernardo Post Office opened in the northern part of the valley, while the Merton Post Office opened in the western part.

The Plaisted House, situated along the east side of Midland Road, became one of the very first homes in Poway when it was built in 1882. Within five years, the area's population would grow to approximately 800 people.

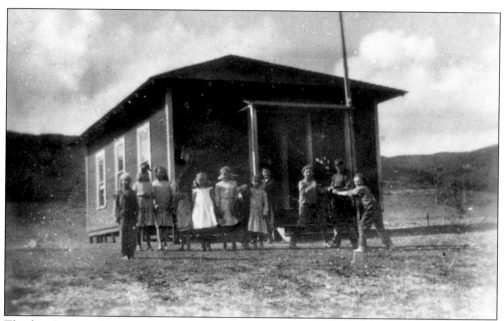

The first Poway School was not much to look at, and its students were not only concerned with homework. Many had to balance schooling with working on their families' farms and helping provide for their families. The Poway School District was organized in 1871, and students were initially taught in private homes. The first schoolhouse was built in 1895.

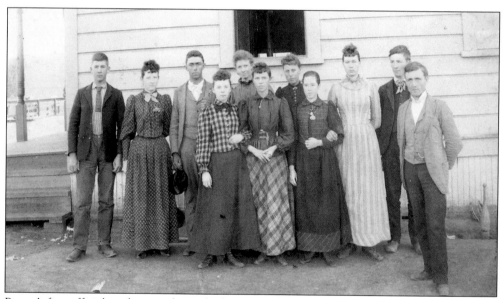

Poway's first official graduating class, which consisted of 10 students, assembles in 1892. Taught by Mr. Durnham, the students were deemed ready for graduation after successfully completing the ninth grade. First they had to pass final exams in arithmetic, spelling, language, grammar, history, and geography. The teacher graded them, but it was up to the superintendent's office to sign off on all exams before any diplomas could be granted.

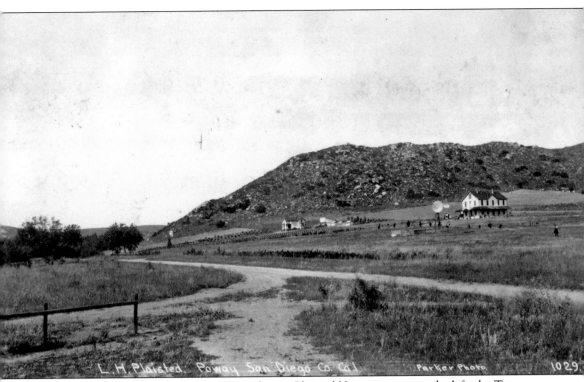

L.H. Plaisted. Poway. San Diego Co. Cal. Parker Photo. 1029.

In this prime example of Poway in 1888, a distant Plaisted House appears on the left, the Terrace Hotel faces Midland Road, and Kent field occupies the background. The name "Midland Road" was chosen when a British developer came to the area with hopes of cashing in on a highly anticipated railroad line in Poway. The railroad never materialized because the area's terrain was found to be unfavorable. The Terrace Hotel was abandoned in the early 1900s when the stagecoach stopped coming to Poway. Before that, however, the hotel, in addition to welcoming wayward travels in search of a bed, was a popular entertainment spot. It provided dancing and dining opportunities for residents and visitors alike.

Elsie Frank (Kahn), shown here, was born on an Escondido homestead to the north of Poway but was thereafter brought, along with the rest of her family, to the area by her father. Her sister Mary Frank (van Dam) was among Poway's first schoolteachers and was later one of its most-famous historians. Mary's memoir, *As I Remember Poway*, was published in 1985.

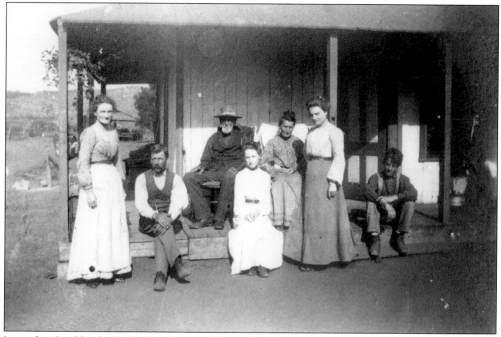

Large families like the Fickas family, one of the earliest known pioneers of Poway, were commonplace in the early 1900s. The Fickas house, which no longer stands, was located near Lake Poway Road off today's Espola Road.

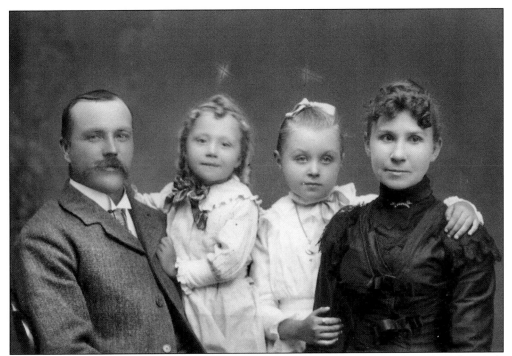

Prominent Poway farmer J. H. Lawson and his wife and two children owned land on the south side of Oak Knoll Road a short distance from its intersection with Poway Road. The Lawson home was built in the late 1890s and razed in 1980 to make way for a new church.

About 1876, C. S. Luce built his house where the Old Ramona Road crossed with the Old Escondido Road. Luce died in this home sometime around 1897 and was buried in Dearborn Memorial Park.

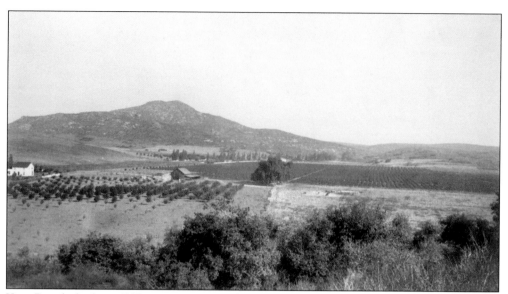

Kent Ranch, built in 1883, grew into a peach orchard that reached its peak in the 1920s. The Kents were among Poway's most prominent families in the early 1900s, alongside the Kears, the Franks, the Freidrichs, the Lawsons, the Hillearys, the Cravaths, and the Witts. Early settlers, arriving between the late 1870s and early 1880s, were fortunate to cash in on an influx of wealthier settlers to the area. Severe drought conditions also allowed earlier settlers to sell off pieces of land they had purchased for cheap to the incoming people with deep pockets.

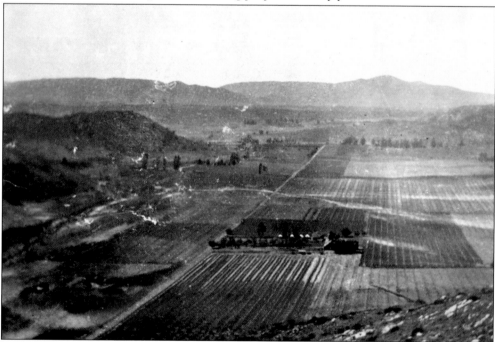

This panoramic view looking north of the Poway Valley in the early 1900s shows mostly wide-open spaces dissected up the middle by Midland Road. The name "Midland Road" was influenced by visions of a British railroad invasion. Early settlers had hoped the line would boost the local economy, but it was revealed that Poway's valley terrain was not conducive to a railroad.

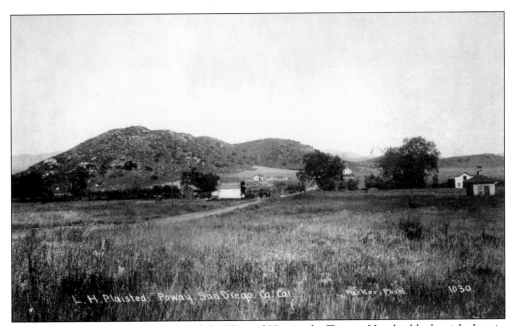

Around 1900, Aubrey Street included the Plaisted House, the Terrace Hotel, a blacksmith shop in front of the hotel, and two white real estate buildings. Also seen are a wooden building that served as a post office and McIvers Country Store. Aubrey was yet another street name influenced by British culture and the hopes that a British railroad company would build a line through town.

Danny Graham and his grandmother Mrs. McFeron settled in Poway in the early 1900s and grew peaches. The McFeron home, situated along what are now Espola and Twin Peaks Roads, was built in 1914–1915 and eventually burned down. Because Poway's earliest fire protection agency was the state's department of forestry, residents encountering house fires in the earlier half of the 20th century had to intentionally set ablaze the surrounding grass in order for the department to come extinguish everything that was on fire.

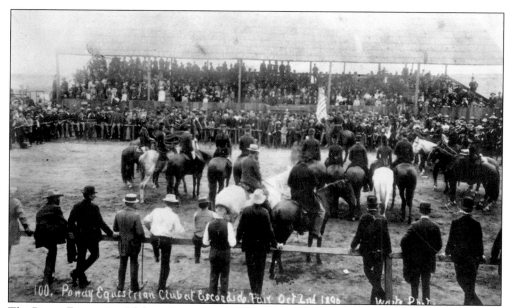

The Poway Equestrian Club performed at the Escondido Fair on October 2, 1890. Poway has long been a home for horse breeding and training, especially of Arabian horses. To help ensure that the area's horse-friendly atmosphere would continue even as the valley developed, the Poway Valley Riders Association was established in 1960 to foster family-related activities around horses.

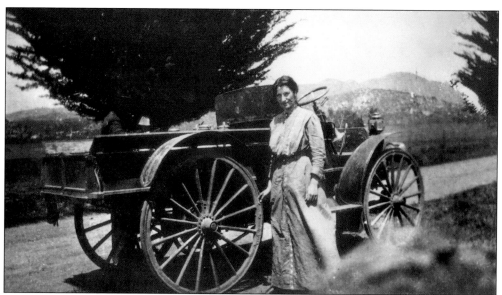

Laura Flint and her family owned an International truck. Popular in the early 1900s, the truck had wooden spoke wheels with hard rubber tires.

Two

SETTLERS SETTLE IN

By the 20th century, Poway, though still decades away from being an incorporated city, had begun to take shape as a real community with a town church and public school system. Early settlers had formed relationships with one another, intent on turning the valley area and its rich soil into a civilized community. Building farms and ranches in the Poway Valley took a great deal of hard, back-breaking labor, and early Poway settlers would reward themselves with social activities. Most everything was a family affair, with children being put to bed in the backs of buggies when the time called for it as their parents celebrated the evenings away with newfound friends. Law and order was not much of an issue for a valley wrought with young families. Tales of the Wild Wild West did not apply in Poway. Access to the area was still quite primitive, with horses and buggies as the staple. Even as automobiles were eventually introduced to the valley, they would be a bit of a novelty until gaining more mainstream popularity after the start of the 20th century.

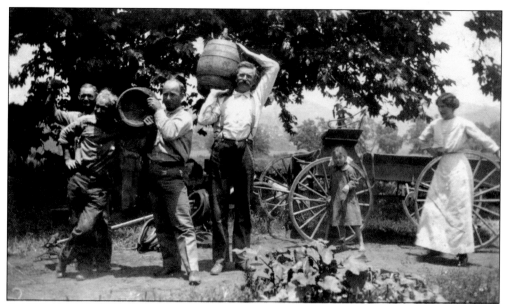

A 1915 picnic at Littlepage Ranch involved a couple of men unloading a keg of something, perhaps wine, and food from a wagon. The Poway Valley's rich agricultural beginnings included the Bernardo Winery, which opened in 1889 and still operates today. Annual hometown reunion picnics remain a tradition. The open-house policy encourages residents to come and share their stories of Poway's past with others.

The Lawson House was built in 1910 on Pomerado Road near the present-day Rexford Terrace area. To the north is the Seventh Day Adventist Church site on Pomerado Road. The Lawson family included two brothers: Will and John.

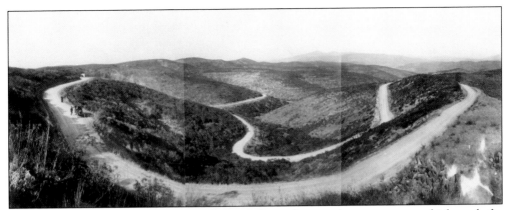

This c. 1910 aerial view of Poway Grade Road shows the street's many curves, which made for potentially rough travel for people going to Ramona. Stagecoach traffic from Poway through Ramona really began around 1870, when gold was discovered in Julian, and the route became one of the few ways to reach the small, remote town at the eastern edge of San Diego County.

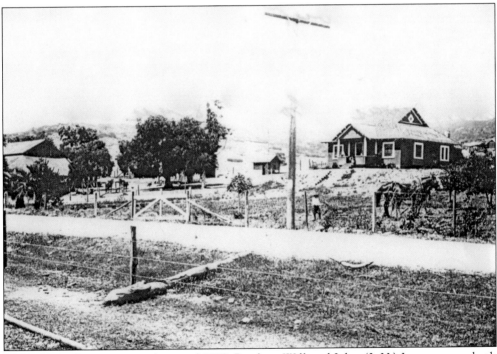

The Lawson farm is pictured around 1910. Brothers Will and John (J. H.) Lawson were both prominent farmers in Poway.

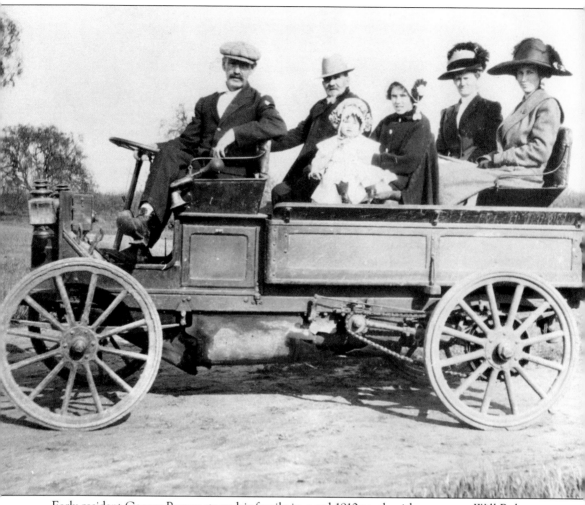

Early resident George Powers steers his family in a red 1910 truck with passenger Will Robeson and other members of the Powers family in the back seat.

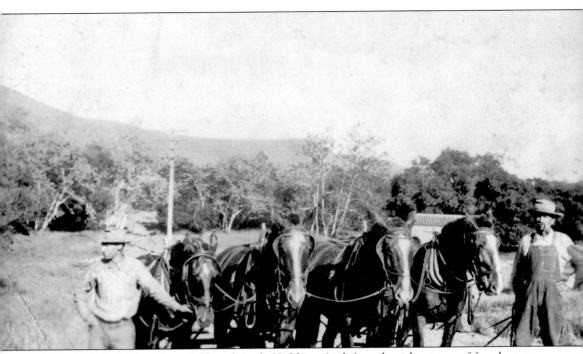

Around 1910, Archie Flint (left) and Andy Kirkham (right) work with a team of four horses belonging to Flint. The men are helping Jim Winfreis with his farmyard.

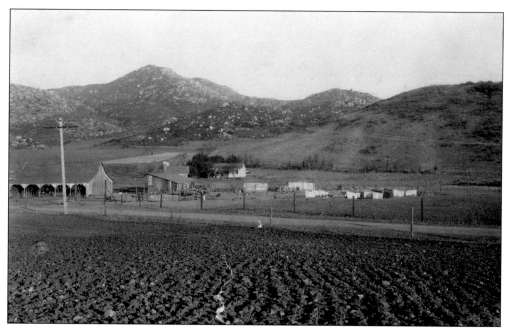

In this *c.* 1910 eastward view, Pomerado Road runs through the John Frank Ranch and dairy farm, and the present-day Twin Peaks Road is at the left rear. The stagecoach line between Escondido and San Diego, started in 1887, drove straight through the ranch. It took approximately eight hours to complete the route one way.

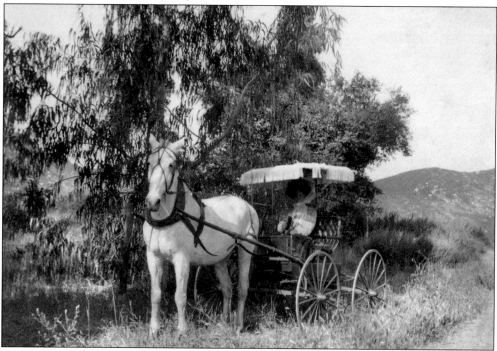

The Escondido-born but Poway-raised Elsie Frank (Kahn) takes a break from farm work to ride in a buggy in 1911. Elsie was one of three children in a small family, at least by early-20th-century standards. Her younger sister's name was Mary, and her younger brother's name was Delbert.

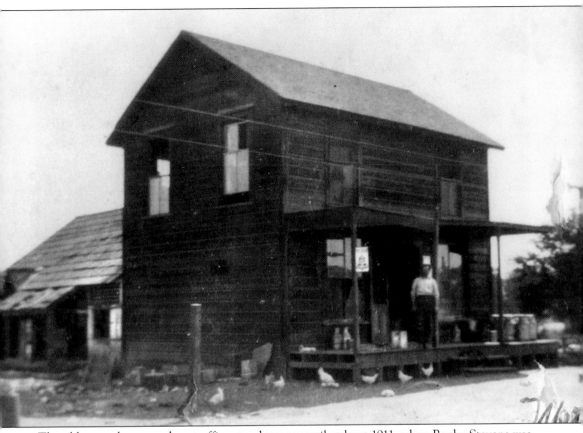

The old general store and post office stood strong until at least 1911, when Rocky Stevens was spotted on its porch. George Kerswill originally constructed the building in 1894. As early settlers arrived, they found laborers amongst the indigenous people who lived in the area. Such workers were of Kumeyaay-Ipai descent.

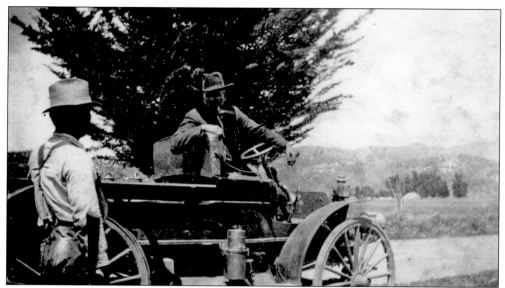

The third horseless carriage ever in Poway was an International truck. Archie Flint sits behind the wheel in 1913 with Ed Littlepage standing nearby.

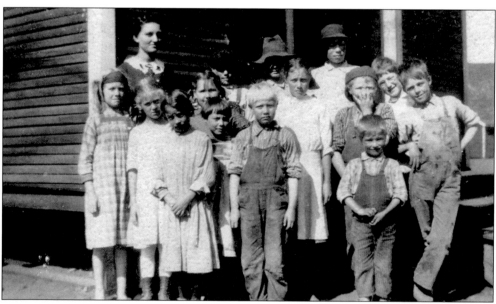

Mary Frank (van Dam) taught the entire Merton School for the 1913–1914 year. Students included, from left to right, Jessie Lawson, Bernice Friedricks, Katie Dragoman, Zelpha Hansen, Bessie Lawson, Hugh Lawson, Hanford Lawson, Walter Hansen, Pearl Lawson, Robert Lawson, Albert Lawson, Martin Dragoman, Eugene Friedricks, and Frank Hansen.

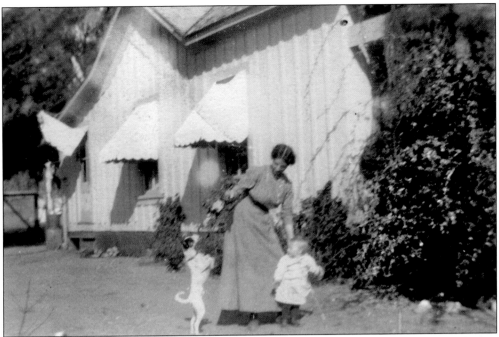

Women, as well as men, tended to hard farm work in the early 20th century even though they also served as primary caregivers to young children and sometimes family pets. As one account states, "Housewives of early Poway led an industrious and hardworking life." They also cooked for the hired farmhands, who generally made about $40 to $50 a month plus free room and board for their services.

Delbert Frank stands in the foreground of this 1914 photograph of the John Frank Ranch and dairy farm. The farm was one of the most prominent in Poway for many years, although the family had originally started farming in Escondido.

The Tenogene Montiel House was built along Espola Road around 1915. The name "Espola" is the product of combining the "es" part of Escondido, the "po" part of Poway, and the "la" part of Lakeside. The road served as an important connector for those three areas.

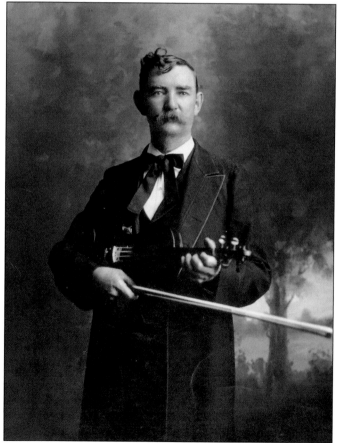

A prim and proper Bob Hargraves, pictured with his fiddle in 1914, was a local Poway celebrity. A common sight at dances at the International Order of Good Templars, Hargraves often teamed with Margaret Jeffries, who played the violin.

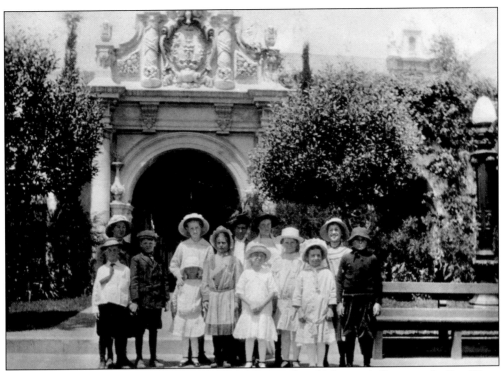

Dressed in their Sunday best, Poway School children explored life outside Poway at the San Diego Exposition on May 21, 1915. Teacher Mrs. H. M. C. Ebert has posed the children in front of the Exposition Building in San Diego's Balboa Park.

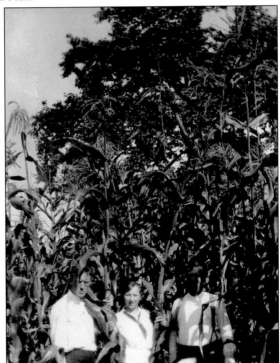

Although not necessarily one of Poway's best-known crops, corn flourished in a field in 1916. Early Poway settlers Sela Lucas and her husband, along with farmer Fred McFeron, practically swam in it, the crop was so bountiful.

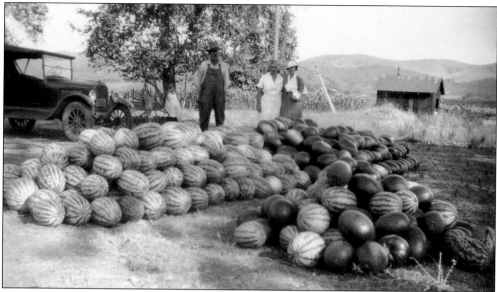

Especially popular with Poway farmers were fruits such as watermelons. Here Archie Flint carefully examines melons from his farm around 1915. Other popular crops included peaches and muscat grapes, which were often harvested and then dried to make raisins exported to San Diego for bigger markets.

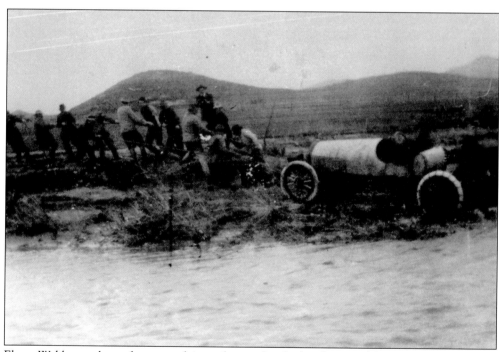

Elmer Webb was the unfortunate driver of a car that had to be towed from Poway Creek near Meadowbrook in 1916. It took about a dozen men to help pull it out, as they lacked the modern conveniences of AAA and tow trucks.

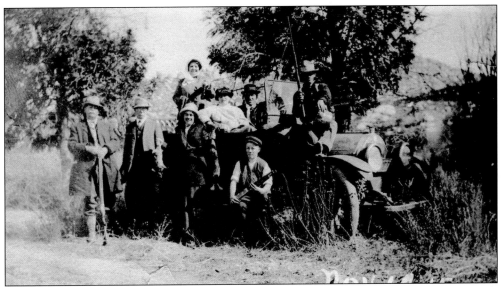

A hunting party is pictured on November 14, 1915, possibly seeking quail. Also popular with hunters in the early days of Poway were rabbits, squirrels, and deer. Coyotes were often caught and sold for bounty. The government paid hunters $5 for each scalp mailed to them.

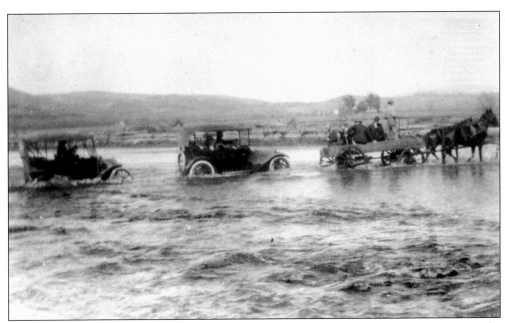

A flood hit the community hard in 1916. This Model T had to be towed by horses and a wagon. The financial loss was never disclosed, but many farms and ranches were believed to be affected.

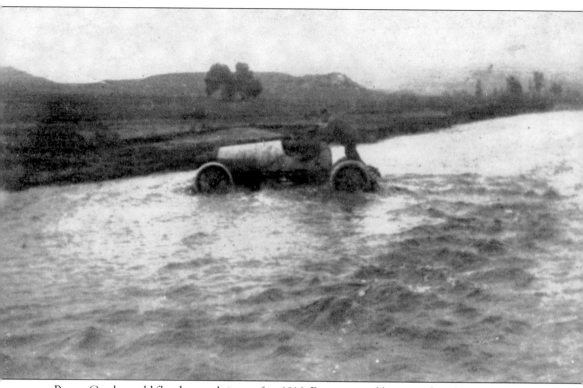

Poway Creek would flood several times after 1916. Damages and losses to date for residents of the past and present are unknown but likely substantial. Historians believe Poway's creek beds led to its name. The early Native American names given to the area generally translate into such things as "here, the waters met" and "the meeting of the little valleys." Indeed, three creeks meet in Poway. Both Rattlesnake and Beeler Creeks run into Poway Creek, with Rattlesnake flowing in from the north and Beeler coming in from the south.

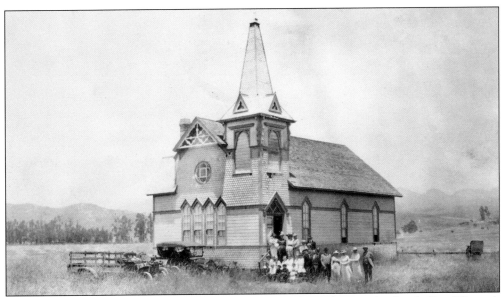

The Community Church, Poway's first church, was captured in a photograph taken by Rev. Ellsworth Smith, its general missionary, in 1916. Building and housing units now surround the church.

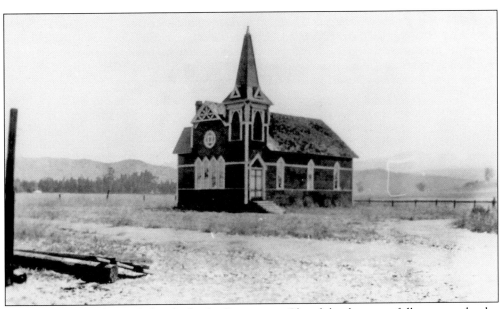

Though it once took on a darker shade, the Community Church has been carefully preserved today with a white exterior and green accents. The building is the oldest in Poway, having been constructed in 1885. It has been used for religious services longer than any other in San Diego County.

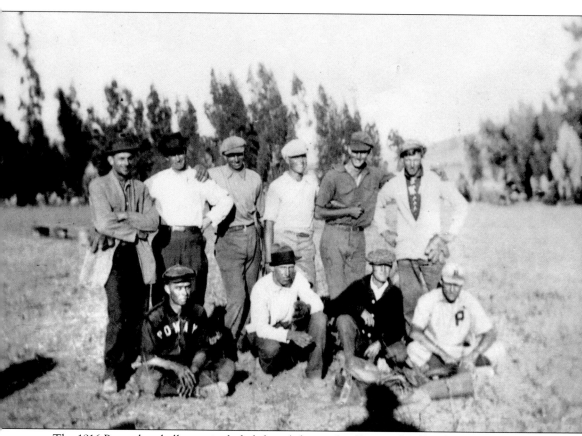

The 1916 Poway baseball team included, from left to right, (first row) Bill Kuhn, Andy Kirkham, Frank Calahan, and Bob McFeron; (second row) Frank Freidrick, Frank Burbough, Lin Volk, Johnnie Lawson, Ray Volk, and Ed Nelson. Organized sport remains a community staple. Debate about whether the city should help build a girls' softball league field and where it should be located brought about the most attended meeting in Poway City Council history. More than 800 residents showed up to protest for and against the plans, which were ultimately approved.

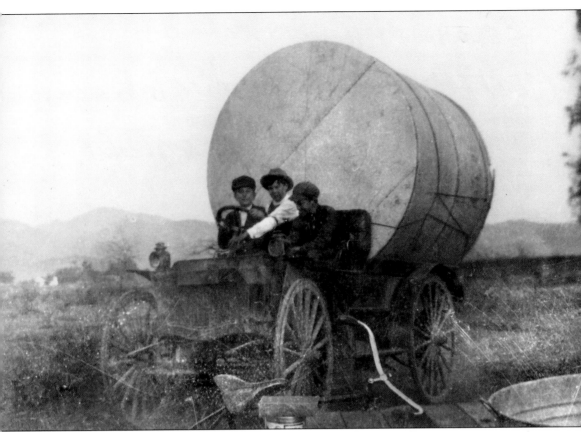

A water tank is transported from Escondido to Charly Clark's place in 1917, a common scene until new ways of providing water to Powegians were developed. Lack of a reliable permanent water source would later delay development in Poway until the middle part of the 1900s. A local water board was then founded by popular vote of the residents, and Lake Poway was later created. All that reliable water made it possible for more homes, via large subdivisions, to come to the area like never before. Those who lived in the earlier part of the 20th century would have many more years of quiet, tranquil, rural living before such rapid development could occur in their community.

In this 1917 view of Midland and Poway Roads, the Mayle General Store and post office appear in the background while the Mayle family is in the foreground.

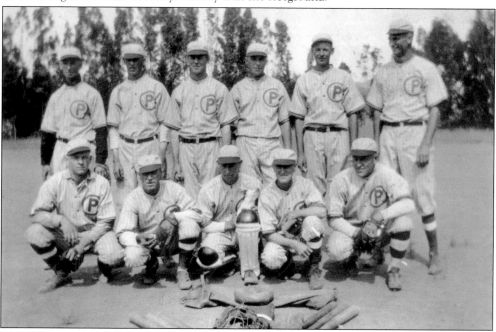

The 1917 Poway baseball team included, from left to right, (first row) Bud McFeron, Andy Kirkham, Harold Brewer, Harold Calahan, and Bob McFeron; (second row) Leonard Brewer, Ed Nelson, Henry Nelson, John Lawson, and Ray Volk. Clifford Carlton "Gavvy" Cravath, a notable local ballplayer not included in this photograph, played in the major leagues.

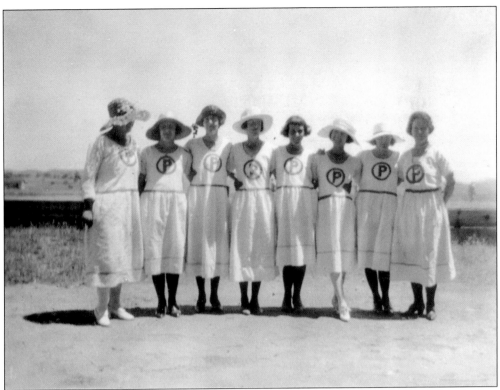

Poway's early baseball team was encouraged by a full-fledged cheerleading squad. Cheerleaders included, from left to right, Mary Nelson, Pauline Mayle, Jessie Mayle, Hilda Nelson, Frances Mayle, Clotilda Mc Feron, Dorothy Mayle, and Marjorie Stevens.

California governor William Stephens and his wife, Flora, visit Poway School in 1918. Stephens served as governor from 1917 to 1923. Flora taught in Poway from 1890 to 1891 under her maiden name, Rawson.

This wide shot of Gov. William Stephens and his wife, Flora, during 1918 pretty much shows the extent of the Poway student body.

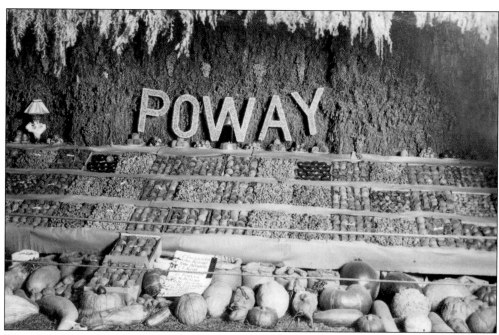

The 1918 Poway Farm Bureau exhibit at the Balboa Park festivities in San Diego showcased Poway as one of the county's most-noted agricultural communities. That is not the case today, as its economy has shifted to major retail chains and a massive business park full of high-tech companies, large manufacturers, and other enterprises.

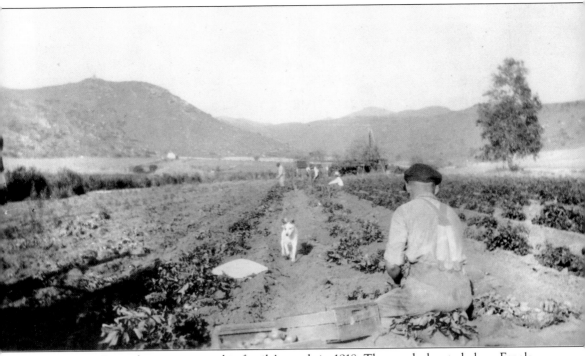

Budwin McFeron digs potatoes on his family's ranch in 1918. The ranch, located along Espola Road, is now the site of many large homes and is a more prominent and costly part of the city. The average single-family house in Poway costs well over half a million dollars and several are in the million-dollar range, especially in North Poway. All of San Diego County is known for its high property costs, but Poway is among the pricier parts, with large estates fit for such things as horse corrals. As in the past, the city maintains a rich love affair with horses and open space.

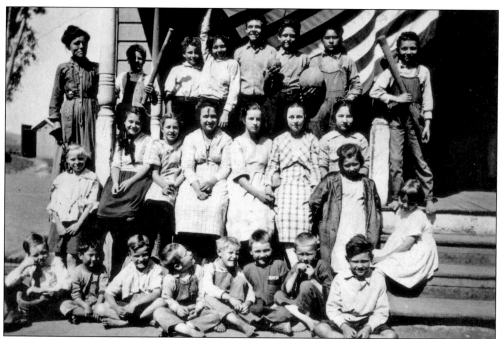

In 1919, Poway School consisted of 24 students and one teacher. The Poway School District, organized in 1871, extended into Linda Vista to the south, Sorrento to the west, Escondido to the north, and Ramona to the east.

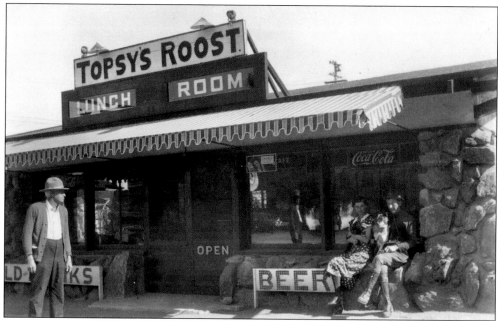

The popular Topsy's Roost Lunch Room, owned by Bert and Minnie Howell, was a common restaurant stop for truckers and the general public along old Highway 395. Originally constructed in 1926 by Dan Struck and Harold Watson, the building is now the Big Stone Lodge. The City of Poway currently owns the lodge and has discussed renovating it. It is not open to the public due to safety concerns.

Three

RURAL ROOTS

It is hard to tell from the looks of it today, but Poway was once bountiful with crops as a rich farming and ranching town. It was the sort of place where farmers and ranchers helped each other. One's son often married another's daughter, and business was always a family affair. A great many crops grew well, from fruits like peaches, grapes, and watermelons, to vegetables such as potatoes. Had it not been for the eventual influx of modern development, Poway today could quite possibly support another rich agricultural community. In fact, the Poway area was left alone as an oasis of sorts from the hustle and bustle of the rest of San Diego County for most of the 20th century. Ignored by most of the other parts of the county, residents would find plenty of enjoyment within their own community when they were not eager to see what else lay outside the valley. Sports and rides in those newfangled automobiles were all the rage. And horseback riding soon became more of a pleasure than a necessary mode of transportation.

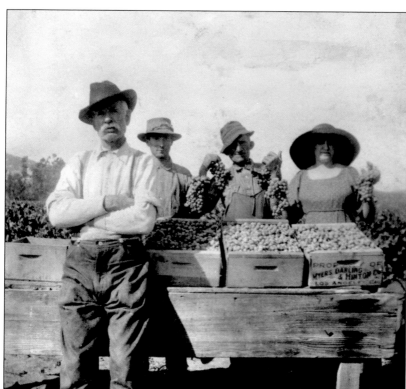

Pictured here from left to right are E. G. Flint, Elri Stotler, Charlie Clark, and Hester Flint packing grapes around 1920. Grapes were a staple product for many Poway farmers, and they were often used to make wine and raisins as well. Peaches were also a popular crop.

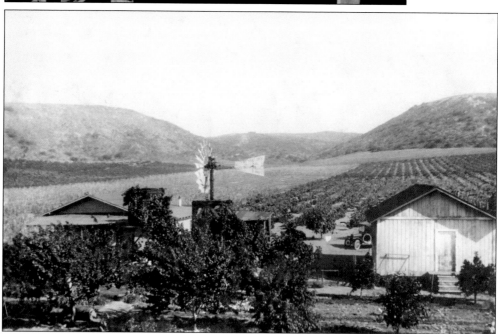

The Savelli Ranch Winery, located in the Garden Road area, produced grapes and wine during the early and mid-1900s. The fields and the buildings covered many acres. Another successful business was the Bernardo Winery, found across town from Savelli in northern Poway. The Bernardo Winery operates today, though on a much smaller scale.

A touring car allows for recreation in 1920s Poway. In the early days, other traveling recreation opportunities included young people renting cabins on the beaches of La Jolla and Del Mar under the watchful eyes of appropriate chaperones. It was not uncommon for groups to spend an entire week frolicking in the sand and surf during summer months.

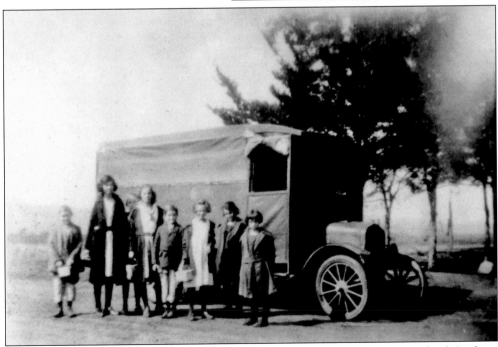

Poway's first school bus provided an alternative to students used to riding horses to school. Students gather in front of the bus, driven by Frank Calahan, in 1921.

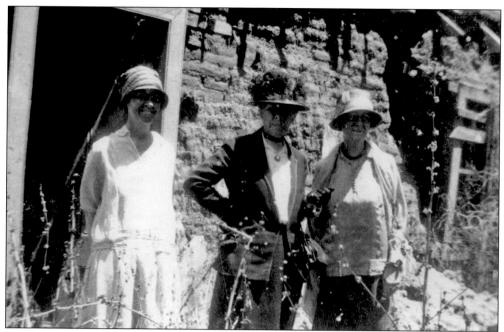

Shown here from left to right are Lola Ward, Kate Kerran, and Elsie Gregg. The three are visiting one of Poway's earliest tourist attractions: the adobe ruins. The ruins are remnants of a former house of the first settler, Philip Crosthwaite.

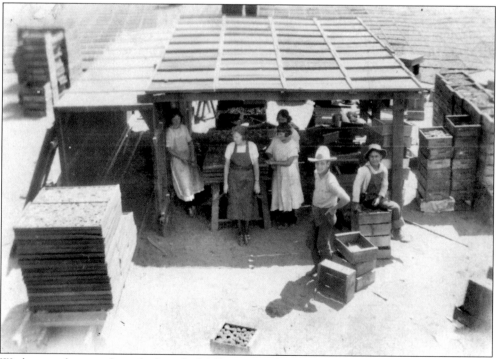

Workers tend to a packing shed on the McFeron Ranch in 1920, putting in their hard day's labor near the corner of today's Twin Peaks and Espola Roads. The drying trays were quite possibly used to dry peaches, as they were a popular crop with the McFerons.

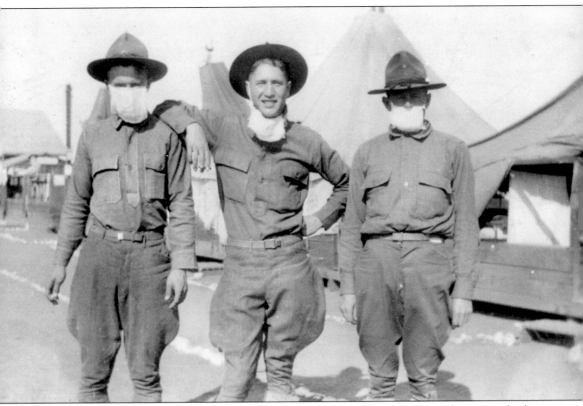

World War I soldiers don flu masks in early Poway. With San Diego's deep military ties, both with the navy and marine corps, Poway played host to encampments when times of war called for it. Today the city also has a fairly active Veterans of Foreign Wars group, the Lt. Fred L. Kent Post 7907. With help from the local VFW post, Poway adopted a marine corps unit stationed at nearby Camp Pendleton in Oceanside: the 1st Light Armored Reconnaissance Battalion of the 1st Marine Division. By adopting the unit, the city and the local VFW post agreed to supply support to the troops via care packages and other morale-boosting events held in town.

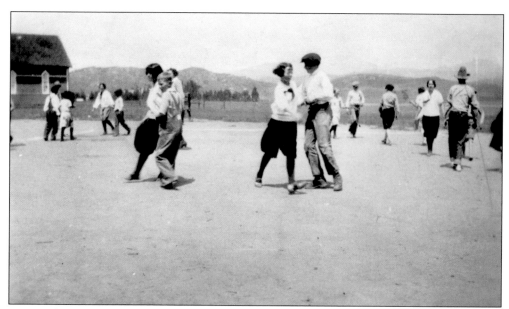

A group dance provides much-needed fun for students in Poway. Other popular recreational activities of the time included horseback riding, hiking, picnicking, and playing baseball. Community dances were often held in halls and attended by the entire family. When they tired from all the excitement, children were often put to bed in the backs of wagons so their parents could stay out and socialize.

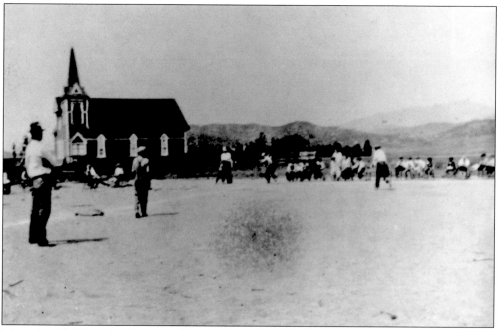

Most schoolchildren played a game of baseball in a vacant lot south of Community Road in the 1920s just for fun. But baseball could mean serious business with community pride on the line, as teams from various San Diego areas often traveled to play one another in highly anticipated matches.

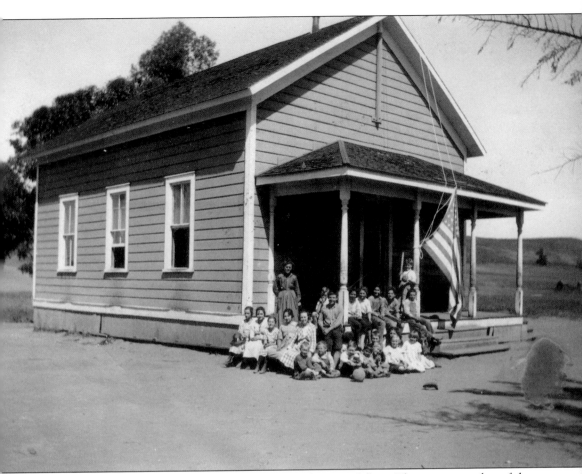

In 1920, Poway School was remodeled by removing the second floor. The average teacher of the day was paid anywhere from $45 to $80 a month. Those who taught prior to the 1900s include the following: Mary E. Hagadorn in 1871 for $45, Frankie Bishop in 1873, Salome E. Wattson in 1874 for $60, Emma Everhart in 1882, Mary Walker in 1885, F. Alice Brown from 1886 to 1888 for $60–$75, Ella Waitneight in 1889 for $80, Flora Rawson in 1890 for $80, Georgia Thatcher in 1891 for $70, Lilian Paris in 1892 for $60, R. L. Durham in 1892 for $80, R. R. Goode in 1892 for $75, E. C. Maxton from 1893 to 1894 for $75, Alberta Gamber in 1895 for $70, and Charlotte Getchell in 1898 for $65.

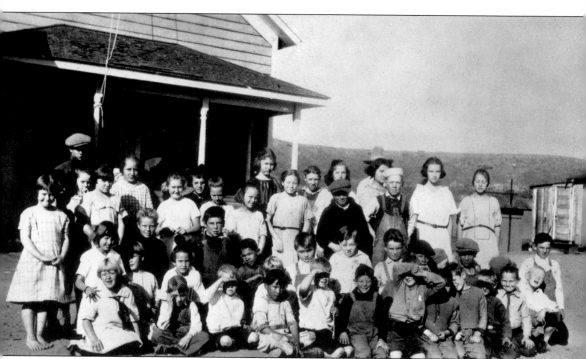

The average student body in the 1920s consisted of 30 students in grades one through eight. Because so few children attended class on a regular basis in those days, Poway joined with districts that had formed in outlying areas to establish the Pomerado Unified School District. The name "Pomerado" was created by combining the "po" from Poway, the "mer" from Merton, and the "ado" from Bernardo. Merton and Bernardo's buildings were moved to be next to Poway's, thus creating a three-room school with two teachers. When Pomerado moved to Midland Road, the original Merton and Bernardo buildings would be transported once more. The Merton building was moved to a private residence on Olive Tree Lane to be used as living quarters. The Bernardo building was moved along with Pomerado and converted to a bus barn.

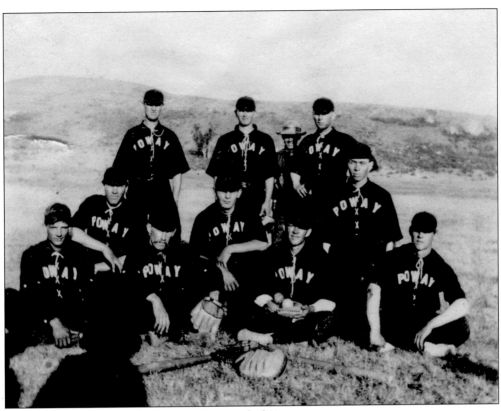

This 1920s Poway baseball team was comprised of 11 men.

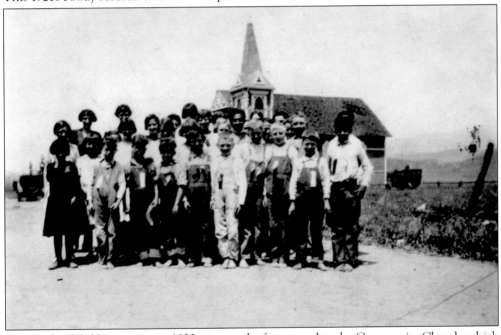

Poway schoolchildren posing in 1920 serve as the foreground to the Community Church, which has since been relocated to Community Road.

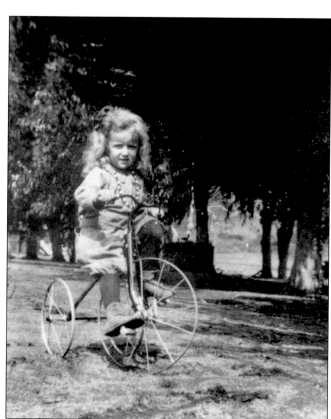

This young girl, riding a tricycle in 1920, is Florence Flint.

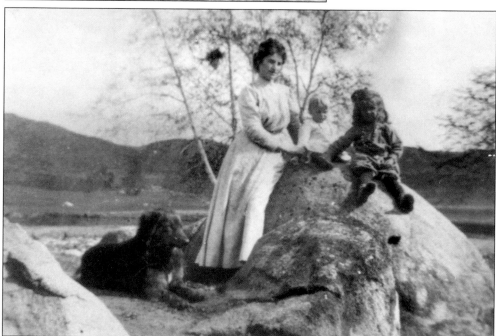

Laura Flint poses with her two daughters, Florence and Francesca, and their dog Rex. The Flints were prominent Powegians in the early 1900s.

The teacher's cottage, called a "teacherette," generally housed single women who chose a teaching career. The building, pictured in 1922, was originally the Merton schoolhouse, located at Hilleary Way and Community Road. It is now part of a residence on Olive Tree Lane.

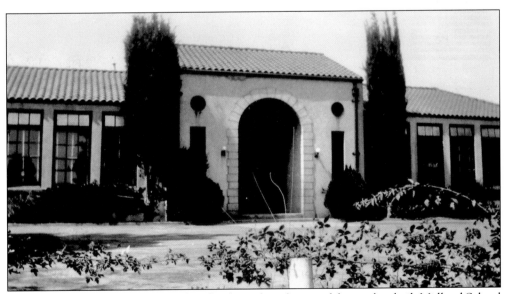

Shown in 1925, the Union Pomerado School stood on the site of the newly rebuilt Midland School near Old Poway Park. The school pays homage to the area's history.

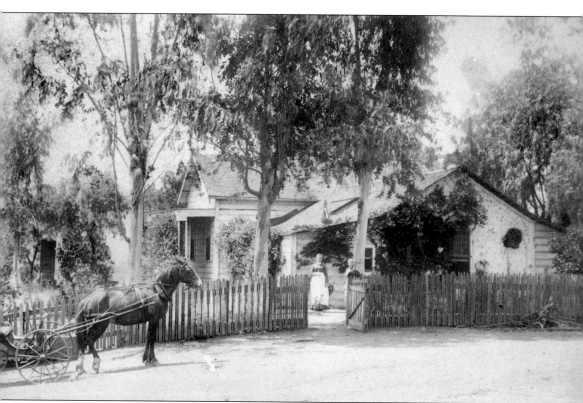

The Sikes Adobe House was the 1920 childhood home of Kate (Sikes) Cravath. It was built in 1868 shortly after Zenas Sikes purchased a 2,402-acre portion of the former Rancho San Bernardo. Today the adobe house sits on a hillside overlooking Lake Hodges and the San Pasqual Valley. At the start of the 21st century, the San Dieguito River Park Joint Powers Association went to great lengths to restore it. An old photograph found by chance inside a Poway Historical Society folder proved very useful. In it, historians were able to examine the past architecture in its best original condition in order to help duplicate it in the present. The photograph bore no date, but the fashions and hairstyles of the pictured women helped place it. In the image, Eliza Sikes and one of her daughters stand behind a wooden fence. It was taken by J. Fortin, a known photographer of family portraits in the late 1880s. The photograph was found among documents gathered on the Cravath family.

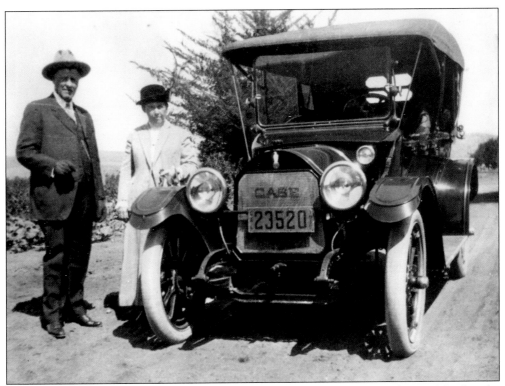

Gus McFeron and his wife owned a prized Case Towering car in 1920. A real gem of the day, the car featured a cloth top.

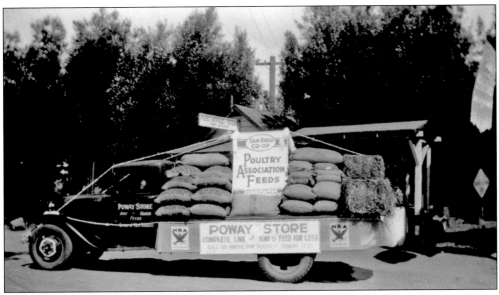

A Poway Post Office and Store truck doubles as a poultry feed truck for William Otis in 1924.

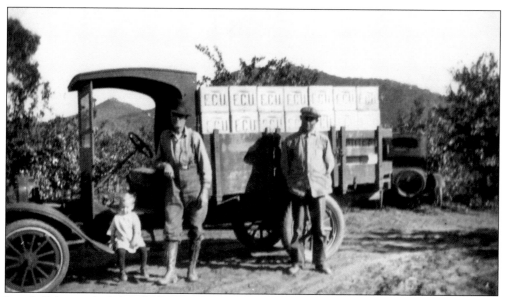

Joseph Sylvester (right) and Charlie Clarida (center), along with a young Warren Clarida (left), pose in front of a farm truck at the Swanner Ranch on Garden Road in 1926. As with most in early Poway, the Swanner Ranch would soon be shut down.

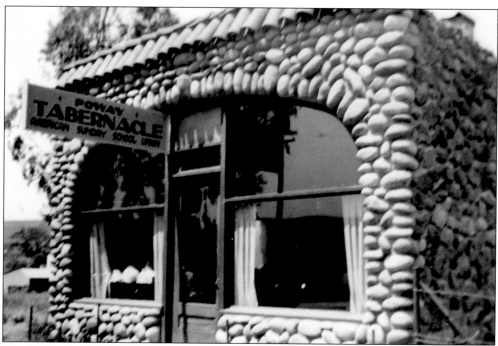

This 1926 view of an old stone-faced building on what is now Pomerado Road shows the architecture of the times. The look did not last long, largely because other styles could be accomplished easier.

The Big Stone Lodge was built in 1926 by Dan Struck and Harold Watson. It was later occupied by Bert and Minnie Howell. In addition, the lodge was once owned by former San Diego Padres player Randy Jones, who ran a barbecue restaurant there for years. Currently, the City of Poway owns the Big Stone Lodge and is considering reopening it after necessary safety renovations are made.

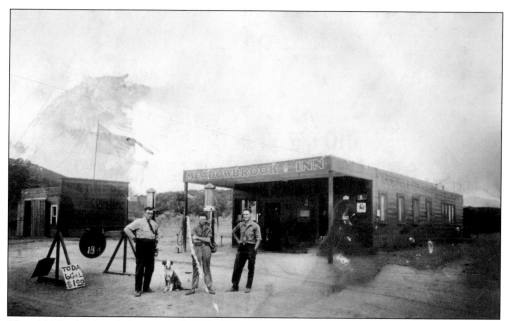

The old Meadowbrook Inn opened on the corner of Pomerado and Poway Roads in 1927 but was shut down after only three years. A service station owned by Harry Harrington (in the black tie) stood on the left. The station would later be sold, allowing for the Chevron gas station that is there now.

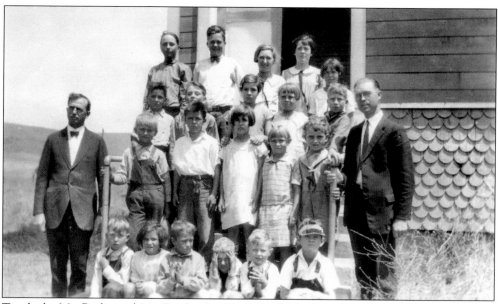

Taught by Mr. Bodie and Mr. Freeland, a Vacation Bible School class stands in front of the Community Church in June 1929.

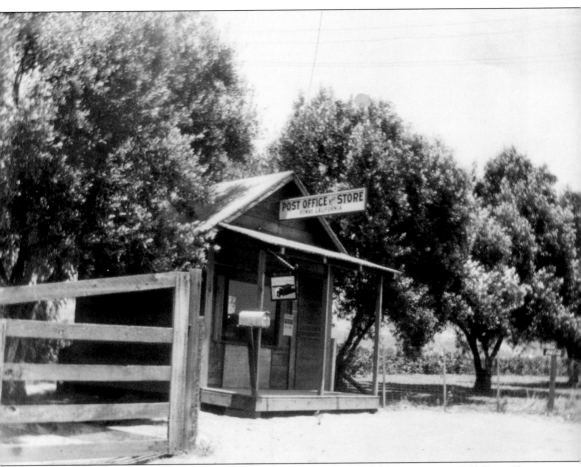

The post office on the Otis Ranch, seen around 1930, was managed by postmaster Bill Otis. The building would later became the site of the Red Bird Tavern, a bar that opened in 1956 and was shut down only recently in 2005. Efforts were made to declare the structure a historic site, but because of so many additions and alterations through the years, it was ineligible and torn down to make way for new development. While it lasted, though, the Red Bird earned a reputation as a real local's bar with no frills, just a lot of regulars, a pool table or two, and owners who knew almost everyone who stepped in by name.

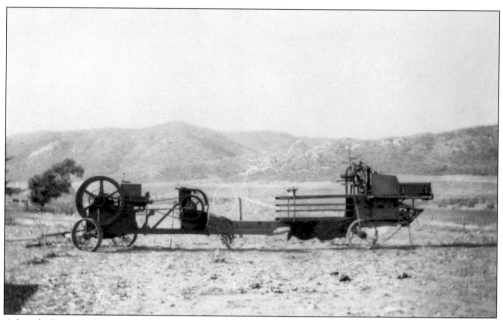

A hay-baling machine such as this one, found on J. H. Lawson's early Poway farm, was the sort of emerging tool technology that made work a little easier on the valley's founding families. Lawson's hay-baling machine was powered by gasoline.

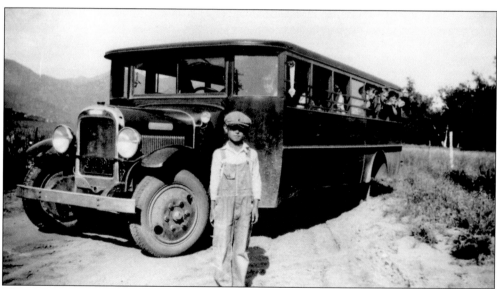

The Pomerado School bus, pictured in 1930, provided a new way for children to get to school without the use of a horse-and-buggy.

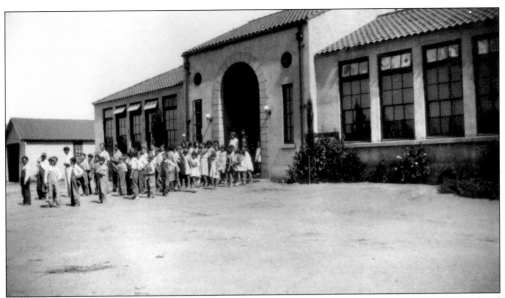

The student body of the Pomerado Union School, shown in 1931, had benefited from a school built only six years earlier.

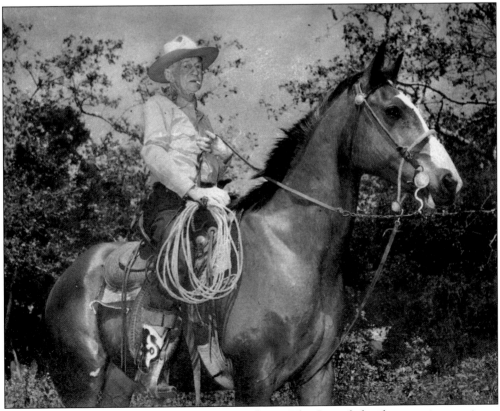

Rancher Ernie Cravath was frequently seen on a horse. The Cravath family was quite prominent in Poway for many years.

Cousins Ernie (left) and Burt Cravath (right) had another cousin who was the major-league baseball player holding the single-season record for home runs until it was broken by Babe Ruth.

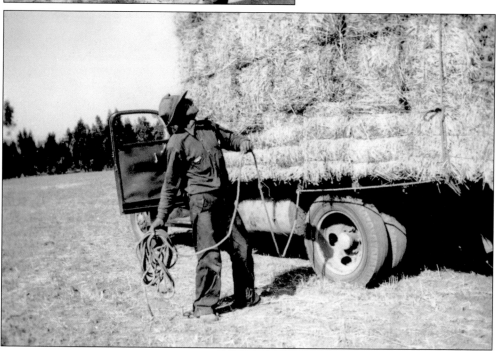

Andy Kirkham secures a load of hay on a truck in 1930, perhaps on his way to market. Selling farm produce was essential to the livelihood of many Powegians.

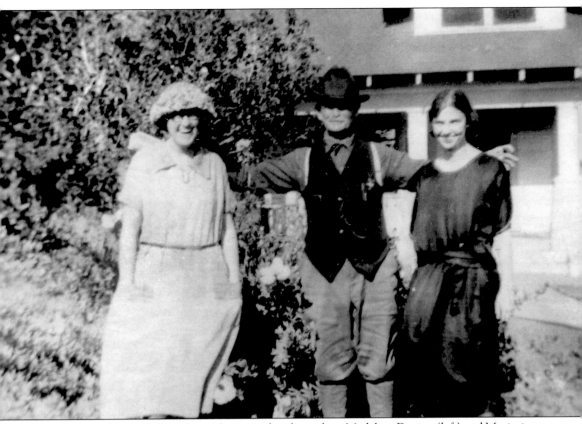

Longtime resident L. E. Kent (center), pictured with teachers Madeline Devine (left) and Marjorie Thompson (right), chaired a committee to get residents of Poway to help bring a much-needed railroad company to the area. The committee was unsuccessful, but the past hopes and dreams for a railroad line in Poway do live on today in Old Poway Park. Local volunteers operate a novelty track that is especially popular with young children, who sit in open-air train cars and enjoy a short trip around the old-fashioned park.

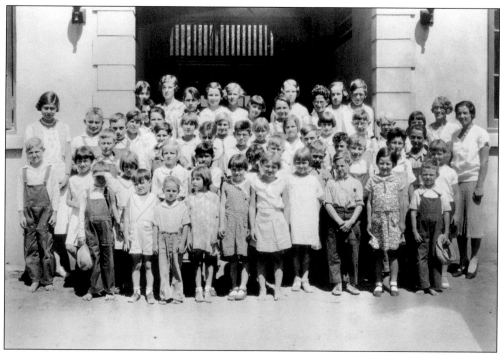

Poway Union School, pictured in 1931 soon after being built on Midland Road, was run by principal Mrs. Schlegel. Two of the teachers were Miss Geddis and Miss Norway.

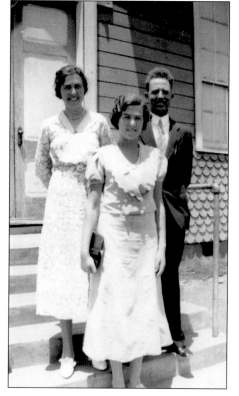

The early history of Poway's Community Church is muddled, thanks in part to the fact it was established long before it had a physical church property. By early 1934, that problem was long solved and a pastor, in this case with his wife and daughter, would give typical services.

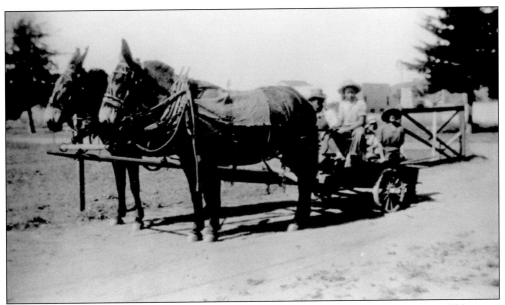

A mule team and cart, such as this one driven by early Powegian Mittie Barton in 1932, was a useful farm tool when used properly.

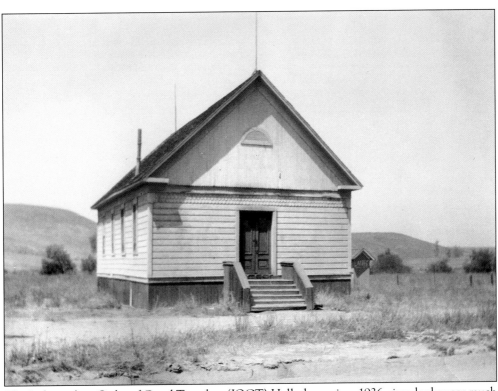

The Independent Order of Good Templars (IOGT) Hall, shown in a 1936 view, looks very much the same today. The building still stands in Old Poway Park and has been used for all types of occasions and meetings through the years. The IOGT Hall was constructed in the 1880s.

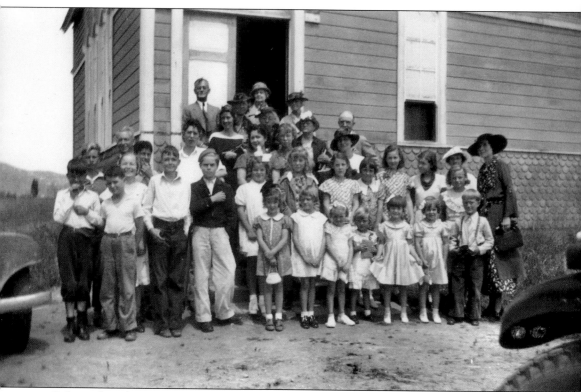

Religion has always played a major role in the lives of Powegians. Seen in this 1937 photograph of the Poway Union Sunday School are (in no particular order) Mr. Merritt, Ella Merritt, Anna Hurtow, Margaret Jeffries Woodey, Effie Kent, C. L. Kear, Mrs. van Dam, Mrs. Anderson, Pastor and Mrs. Rollins, Milton Merritt, and Walter van Dam, along with a number of unidentified children. The Rollinses arrived in Poway in 1932. F. Rollins, an ordained Baptist minister, volunteered to plant eucalyptus trees around the church after giving the structure a fresh coat of white paint.

The Poway graduates from Escondido High School in June 1939 included, from left to right, Raymond Friedricks, Margaret Rasmussen, Edward van Dam, Wynette Watson, Earl Barton, and Juanita Watson. Despite efforts to bring a high school to Poway sooner, secondary education could only be gained by traveling northward to Escondido during the first half of the 20th century.

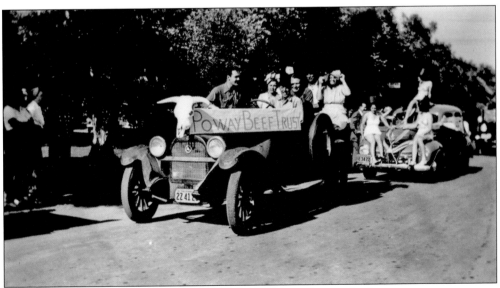

In 1939, the Poway Parade included the Poway Beef Trust float on display.

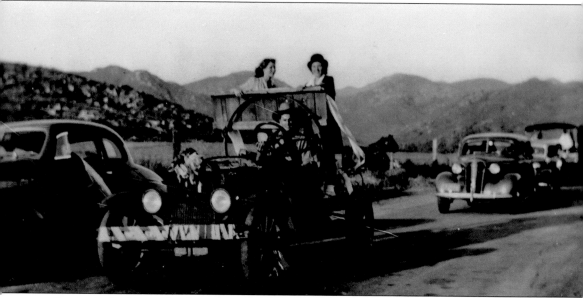

Entries in the Poway Parade on June 23, 1939, show off residents as well as automobiles. Parades continue to be a tradition, with a major one each fall on what has come to be known as Heritage Day. In addition to an early morning parade down Poway Road on a west-to-east path, on Heritage Day, residents gather for a large community pancake breakfast hosted by a service club and a fair-like celebration in Community Park where local businesses and groups set up booths and sell merchandise and food. Local entertainers, from dance troupes to school bands, also often attend. The entire day is part of a larger two-week celebration that welcomes the Poway Rodeo to town.

Four

A SLEEPY ERA

Sometime around the early to mid-1900s, the area known as Poway, not yet an incorporated city, appeared to go into a deep, peaceful sleep. Families ran farms and ranches, and socialized amongst themselves. But progress and development were lacking for several decades as the infrastructure of the time led to a simpler life. The biggest issues of all were the lack of both a dependable water supply and a high school. Families who called Poway home in those days lived off wells. Some were even said to pick up all their belongings and leave because Poway had no high school. Because of this, early Poway teens and their families who chose to stay had to work with the next best thing: going north every day to Escondido to attend its high school.

Eventually, the water supply problem was fixed, and Poway High School was built in 1962. Home subdivisions, big by the day's standards, made their way in and so did modern technologies such as the television set. The first television set in Poway could be found at a place called Koch's Bar on Pomerado Road across from a still-open Big Stone Lodge. Records indicate that with its newfangled contraption Koch's Bar was packed every Tuesday and Thursday night as the community gathered to watch television together.

Ed van Dam, the husband of Poway teacher and historian Mary van Dam, sits under a cypress tree at the Taunt Home in the late 1930s or early 1940s. The property was located east of Community Church between Community and Midland Roads.

A young Carol Christian enjoys her ice cream treat while taking a short rest from riding her bicycle in a representation of the carefree, sleepy days of Poway in the 1940s.

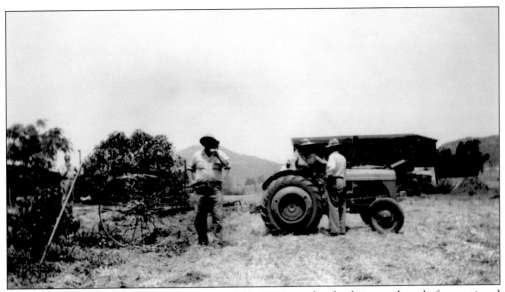

Florence Chambers, seen baling hay in a field in 1940, put her back into it long before national World War II sentiments for Rosie the Riveter encouraged women to work as their men had done before going off to fight. Such was the life of an early Poway woman.

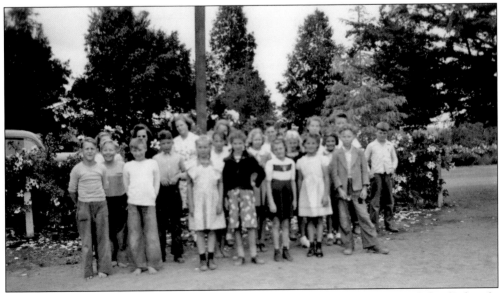

During the 1943–1944 year, principal Florence Colby led Pomerado Union School's fourth, fifth, and sixth graders. One of the teachers was Mary van Dam. Pomerado would soon become Midland Elementary.

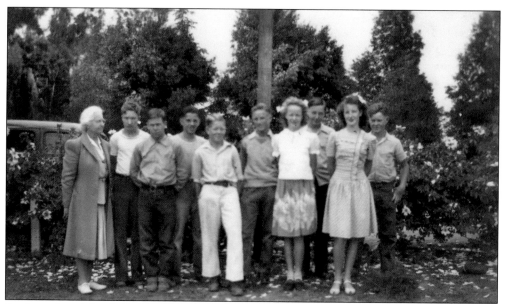

Students from Miss Colby's Midland School class of 1944 pose for a portrait almost entirely in the same posture. Pomerado School was renamed Midland after it moved to Midland Road.

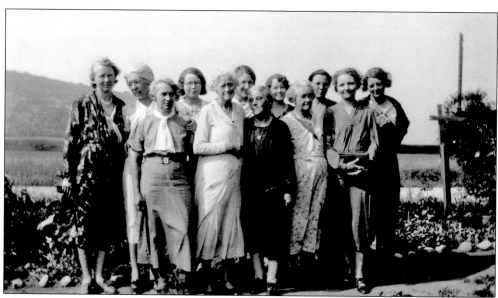

The Farm Bureau Group, a popular Poway women's group around 1944 and 1945, served a double function as a social club and business networking opportunity. The men of Poway formed a similar club just for themselves and called it the Poway Chamber of Commerce. Members of the women's group shown here included (in no particular order) Anna Harlow, Margaret Jefferies, Josephine Fredericks, Gladys Stevens, Effie Kent, Pauline McFeron, Nancy McFeron, Elsie Kuhn, Helen Powers, and three unidentified. This group, while social, also acted as a representative for the area's farmers.

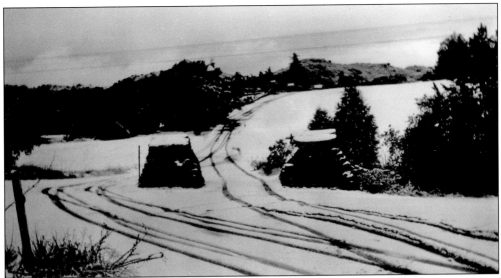

Although not typical for the area's climate, snow blanketed the Mount Woodson area in 1949. Poway experiences about 9.6 inches of annual rainfall and an average temperature of 54 degrees in January. Come August, the average temperature is 76 degrees.

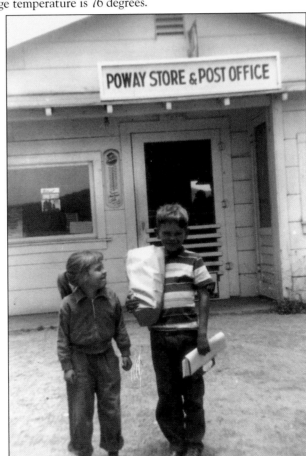

In 1952, Dave and Susie Millard stand in front of the old Poway Post Office where a small grocery market called Plowboys would eventually open along Midland Road. A new post office was built a little farther south on Midland Road in 1967.

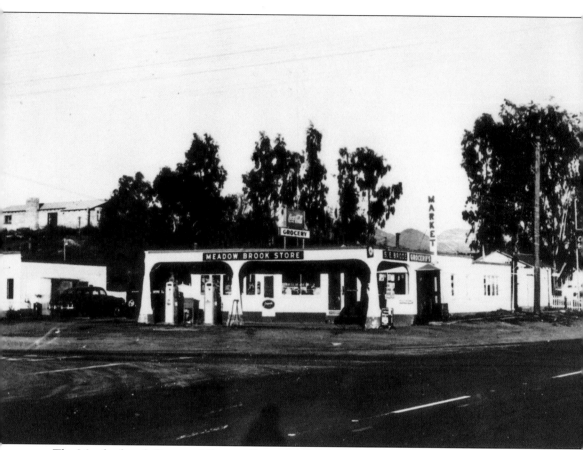

The Meadowbrook Store and Service Station on Pomerado Road was a common stop for many area residents. The first subdivision project, the Poway Valley Homes, came to Poway's east side in 1958. The first real shopping center was Poway Plaza, located on the corner of Poway and Community Roads.

The current post office on Midland Road, pictured in the 1960s, is now largely hidden by carefully landscaped bushes.

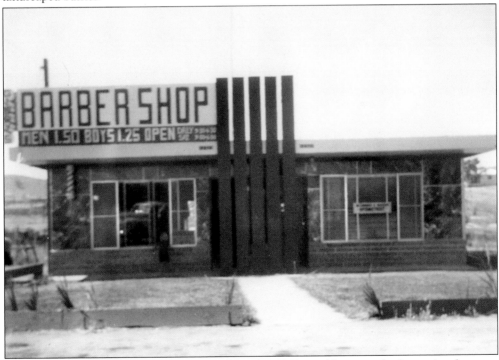

Gibby's Barber Shop, built at 12323 Oak Knoll Road in 1960, would serve as the future site of present-day apartments. The area is looked after by the South Poway Residents Association, a group assembled in the early part of the 21st century to protect the interests of South Poway residents.

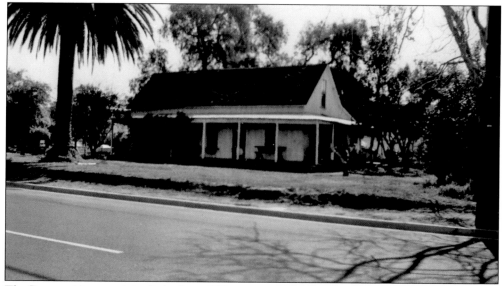

The Bowron House, originally built in 1890, appears in 1964 as a typical residence of the 1960s. In 1964, a home in Poway sold for $19,000, giving the average family a mortgage payment of about $89 a month.

The house of John Dearborn, one of the earliest settlers in Poway, was built in 1883. Dearborn was born in 1841 and died in 1886. Upon his death, he became the first Poway resident buried in the Poway cemetery, giving it its name, Dearborn Memorial Park.

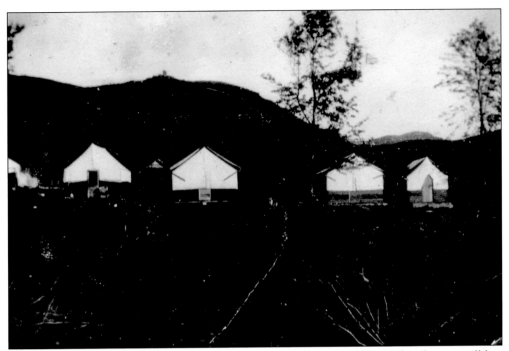

Temporary marine corps tents were set up in Poway in the early 1960s. Today the city still has special housing for military families as a spillover from surrounding bases in San Diego County, including Marine Corps Air Station Miramar.

A newly formed Poway Municipal Water Board brought Colorado River water to Poway in 1954. The important step to sustaining Poway as a modern-day city led to an annual Water Festival where community members were invited to come out and learn about the water supply process.

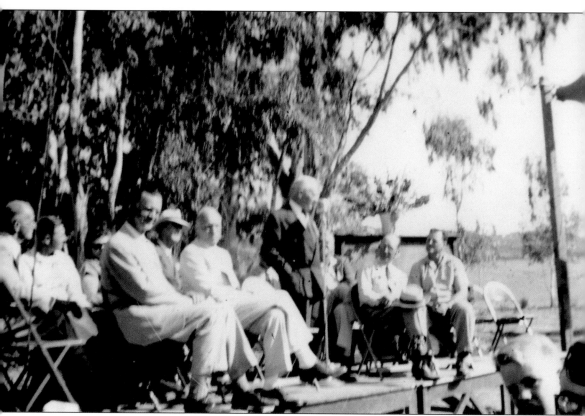

Dignitaries at the Water Festival, an annual Poway event until the mid-1900s, gave speeches to eager residents excited about a permanent water supply. Ironically, a strong water supply paved the way for more development, eventually edging out Poway's agricultural roots. A public vote resulting in 210 in favor and 32 against on January 29, 1954, led to the creation of the Poway Municipal Water District. The first meeting of the board of directors occurred on February 3, 1954, at the Pomerado School, now known as Midland Elementary. The first five directors were David Shepardson, Harry Frame, Harry Tassell, David Williams, and Robert Tobiasson. A second related water vote was taken on March 25, 1954, in order to decide whether Poway should remove itself from the San Diego County Water Authority. Yet a third vote was held on April 22, 1954, to determine whether residents wanted to support a $600,000 bond measure to build a new Poway water system.

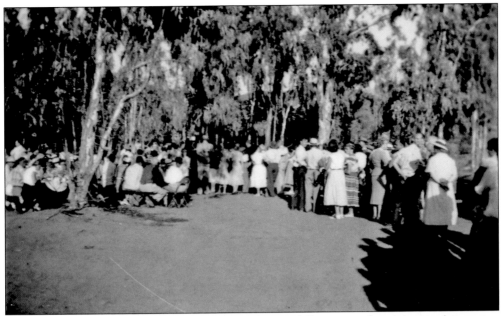

The Water Festival presented the opportunity for a real Poway social activity involving men, women, and children.

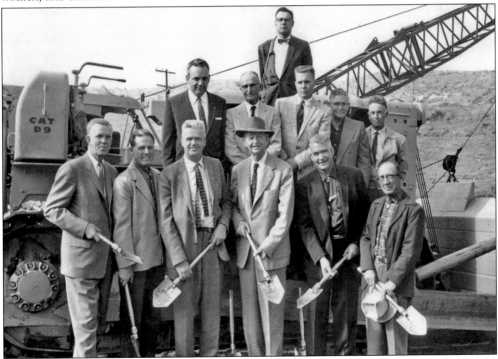

In January 1954, the ground-breaking ceremony for the second aqueduct was attended by the Poway representatives of the San Diego Water Authority. Attending representatives included, from left to right, (first row) supervisor Dean Howell, Homer Williams, David Shepardson, Fred Heilbron, John Sparkman, and Harry Frame; (second row) Max Berlin, Harry Tassell, Lester Berglund, Rubin Tannenbaum, and John Kent; (third row) Don Short.

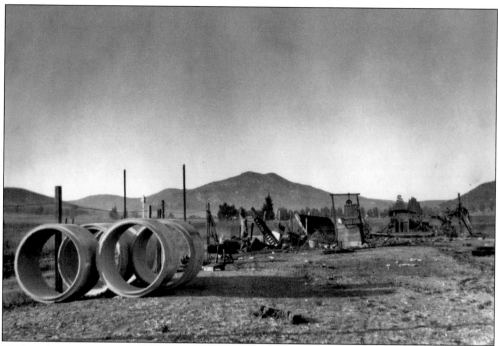

During the construction of the aqueduct in 1954, a bulldozer helps lay the pipes. The building of the aqueduct was a milestone in bringing water to Poway. The first water courtesy of the new Poway system was delivered in July 1954 to Gordon's Grocery on Garden Road.

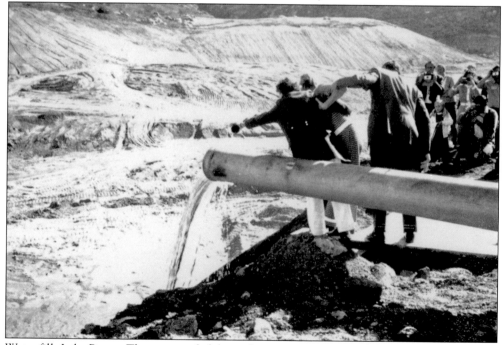

Water fills Lake Poway. The man-made lake and its accompanying park land consist of 50 acres. The Poway Dam was built in 1972 to provide a more dependable supply of water to the city's residences and businesses.

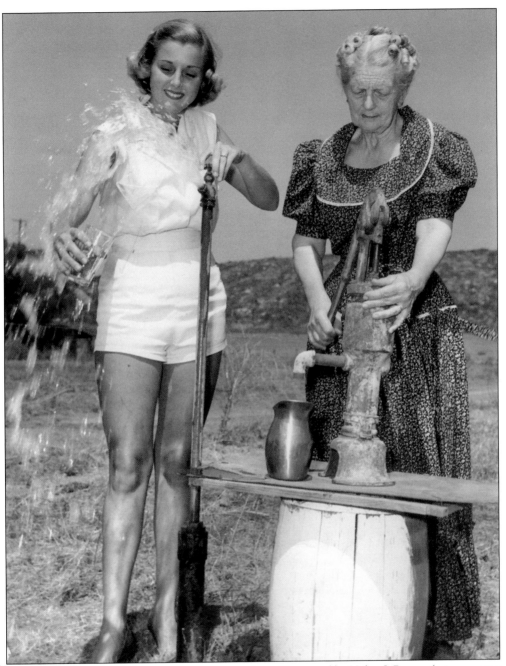

The old and new ways, where water is concerned, are illustrated by Helen J. Powers (using a water pump) and Kay Miller (using a tap to fill a glass of water). The demonstration was orchestrated at the dedication of the Poway Municipal Water District in 1954. Water not only brought more residents and development to Poway, it also helped bring a real fire department. The water district established Poway's first fire department. Prior to this, residents and business owners had to rely on the state and its firefighters, who dealt only with forest fires. Because of this muddled early setup, if a Poway home or business caught on fire, residents would run out and set their grass ablaze to get the forest firefighters to come put it all out.

The Green Valley area is starting to be built up in this image of Poway around 1955. Old Coach Road, the location of the present-day Maderas Golf Resort, is shown in the upper left corner. Residents of the Green Valley area are especially active in Poway politics today. The Green Poway Civic Association has been known to endorse city council candidates, as well as come out vehemently opposed to development proposals that North Poway residents believe would be detrimental to their quality of life. North Poway is arguably the most affluent part of the city and is where many celebrity athletes have chosen to call home for the privacy it brings.

This view looks north on a more-developed Poway Road. Powers Dairy is visible in the middle, and the new post office (1985) is along Midland Road in the upper right along with the intersection of Poway and Community Roads.

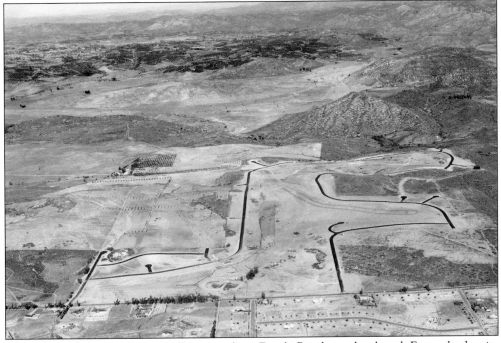

During the 1960s, the Green Valley area along Espola Road was developed. Formerly the site of ranches and farms, this location is now the site of many exclusive North Poway homes. The Bernardo Winery, established in 1889, is still visible in the left center, however.

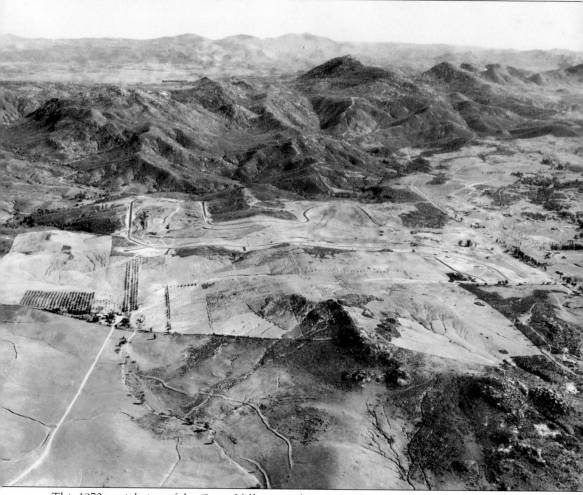

This 1970s aerial view of the Green Valley provides another look at the Bernardo Winery on the left. Today the location is a very densely populated residential area in North Poway. Because of its unique situation beyond the city limits, the Bernardo Winery can be considered a jewel of both Poway and the San Diego suburb of Rancho Bernardo. Since the winery's front faces Rancho Bernardo, it has a San Diego mailing address, but much of the property itself sits on Poway land. The Bernardo Winery is more than 100 years old, having been founded in 1889 on what was a Spanish land grant. The original owners struggled through Prohibition and, in 1927, sold it for a real deal to a family with Sicilian roots who still operates it today. The Bernardo Winery property is not quite as large as it once was, but with imported grapes from various regions of California, including Paso Robles, Monterey, Rancho Cucamonga, and San Diego County, it is still very much a functioning winemaker.

Five

A City is Born

Somewhere in the middle of San Diego County, slightly to the north and east, lies a city that did not exist more than 30 years ago. That city is Poway, which has earned a spot as one of the most desirable places to live in San Diego County because of its quiet, small-town feel. Dubbed "the City in the Country," Poway is roughly the same physical size as its older, more-established city to the north, Escondido, but this comparison is hard to tell when in town. Perhaps that is because much of Poway's geography has been set aside for open space, and its actual population is much less than Escondido's.

Although it is "small" in feel, make no mistake: Poway is indeed a city with a large and profitable business park, a distinguished school district, a praised hospital, an active community service sector, and impressive parks and recreation facilities. Among the generally accepted translations of the word Poway is talk about where the waters and valleys meet. Many of the same people who helped incorporate Poway as a city nearly 30 years ago are still in the community today to help ensure its smart growth. Like parents to a child, elected community officials and volunteer activists weigh in regularly on proposed projects.

The famous Old Poway Park is pictured here. The symbol of Poway for many years, this tree finally had to be removed in the early part of the 21st century because of irreversible rot. A small group of community activists tried to save it by chaining themselves to the trunk, but city officials persisted, saying that the tree could fall on passing traffic at any time and it had become a safety issue. What could be salvaged was turned into various objects small and large, including a conference table for the new city hall complex. (Courtesy City of Poway.)

The first Poway City Hall was built at Civic Center Drive and Community Road. Dedicated in 2004, the present building was named the James L. Bowersox City Hall after the former city manager. Bowersox was hired in March 1981, just three months after Poway's incorporation. He retired upon the city's 25th anniversary in December 2005. According to his peers, Bowersox put "his stamp on the city more than anyone else" and remains active in the community.

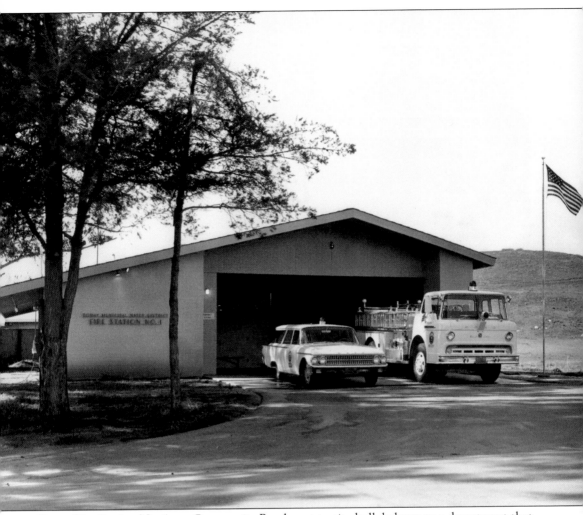

Poway Fire Station No. 1, on Community Road next to city hall, belongs to a department that started in 1961 with Jim Westling as its chief. The Poway Fire Department began with only one fire engine and all volunteer firefighters. By 1964, a second engine had been added and career firefighters hired. Some volunteers were still in high school when they began defending the area. The Poway High Explorer program sent teens out of class when needed, armed with rubber coats and construction helmets. The fire department got paramedics in the 1970s after raising enough money to send six firefighters to a local university for medical training. The community raised $35,000 to cover tuition and the temporary hiring of more workers by launching the A Buck-a-Head for Para-Med campaign. Firefighters went door-to-door asking every Poway resident for $1 apiece. It took just six weeks to get everyone on board.

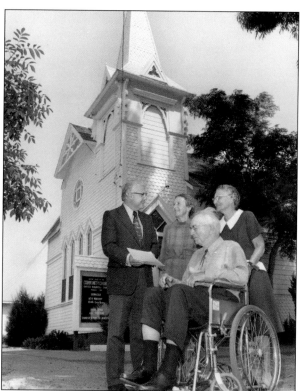

Pictured from left to right are Ed and Mary van Dam, Ernest Fowler, and Lucille Kent as they make some sort of presentation outside the Poway Community Church. Standing on Community Road, the church is the oldest building in Poway and is still in use today.

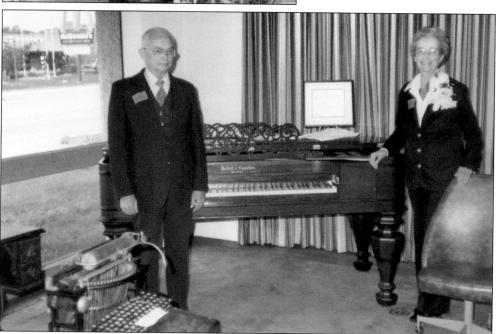

Mr. and Mrs. Mary (Kent) Finley present a piano to Palomar Savings and Loan on Poway Road on March 6, 1981. Although drive-through teller systems were invented for automobiles to use, it was not uncommon in Poway to see a horse stroll up to a teller window with a rider eager to do his or her banking, even in the mid-20th century.

In Poway, known as a family-friendly community, holidays are generally celebrated with annual events put on mostly by the city's community services department. An Easter egg hunt is a staple. Family events are also regularly held both indoors and outdoors at the Poway Community Library. Dedicated to the citizens of Poway on June 13, 1998, the library runs an annual summer reading program that includes various music and comedy events, as well as arts and crafts opportunities for children. (Courtesy City of Poway.)

The Poway Center for the Performing Arts has a capacity of 800 and is owned by the city. Formed as a nonprofit in 1990, the center books professional artists to perform at its space, which is also used by local students and art groups to display everything from high school musicals on the main stage, to watercolor paintings in the lobby. (Courtesy City of Poway.)

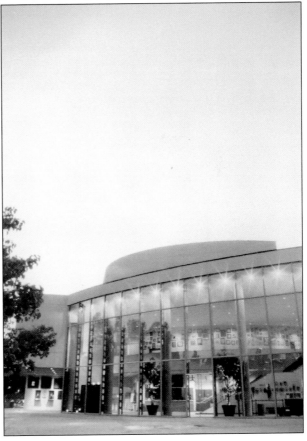

Hiking in Poway is relatively easy and accessible thanks to the city's decision to dedicate several thousands of acres to open space preservation. Perfect examples include the Goodan Ranch and Sycamore Canyon Open Space Preservation. Sycamore Canyon consists of 1,700 acres of coastal sage scrub and chaparral-covered hills. Its 10 miles of hiking trails all wind through southeast Poway. Poway is not the only entity making sure this area stays as nature made it. The area is jointly looked after by the Cities of Poway, Santee, and Lakeside, the California Department of Fish and Game, and the County of San Diego Department of Parks and Recreation. The preserve was severely ravaged by the 2003 Cedar Fire, but much has grown back. Regular users of the preserve, beyond the individual hiking party, include the San Diego Tracking Team and the San Diego Mountain Bike Association. (Courtesy City of Poway.)

The entrance to the Blue Sky Ecological Reserve welcomes Poway residents and visitors to 700 acres of pure nature. A 1.1-mile hike under a canopy of 200-year-old trees shows off the area's ecosystem. (Courtesy City of Poway.)

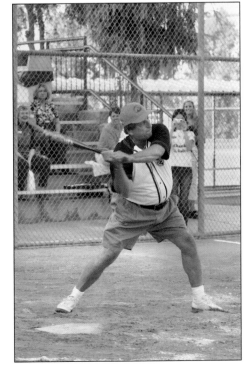

Mayor Mickey Cafagna, who first took office in 1998, is a regular sight at the annual city-versus-chamber softball game. The annual match-up puts bragging rights on the line to see who can assemble the better team each year: city staff or the Poway Chamber of Commerce. (Courtesy *Poway News Chieftain.*)

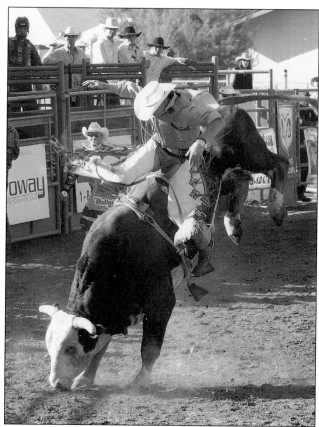

The Poway Rodeo has been a tradition in town for over 30 years, longer than Poway has been a city. The rodeo, which is held mostly each September at the Poway Valley Riders Association Arena, brings in professional rodeo athletes from all over the country. More than 1,000 local residents flock to watch the rodeo over a three-day span. And while many of the rodeo participants are in fact part of a larger circuit traveling all over the country to compete, some local residents also take to the arena. Young girls especially like to compete in barrel-racing competitions, and even youngsters brave the snarl of the mutton-buting event. A crowd favorite, the mutton-buting competition involves little cowpokes riding sheep. A local Miss Poway Rodeo is crowned each year. Unlike traditional pageants, the rodeo tests girls not only on their speaking and poise, but also on their horse knowledge and riding. (Courtesy *Poway News Chieftain*.)

Earth Day is celebrated with as much fanfare as any other holiday in Poway. A multitude of different plant and animal species can be found in Poway today, including oak woodlands, lilacs, lemonade berries, bobcats, rattlesnakes, and scrub jaybirds. (Courtesy *Poway News Chieftain*.)

Christmas in the Park features a community Christmas tree–lighting event, as well as music and treats for children and adults. Another popular way of celebrating the winter holidays is with the annual Candyland Holiday Festival in Community Park. The park is transformed into the popular kid's board game, with the added bonus of tons of fresh snow brought in just for the occasion. (Courtesy *Poway News Chieftain*.)

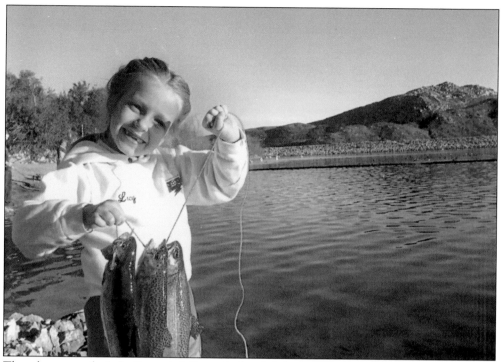

Though man-made, Lake Poway is fully stocked with fish, such as trout, for regular fishing derbies enjoyed by serious adult enthusiasts and children of all ages. Trout season generally runs from November to May. At the beginning of the season, the lake is stocked with approximately 3,000 pounds of rainbow trout; another 1,200 pounds of trout are added weekly for the duration of the season. (Courtesy City of Poway.)

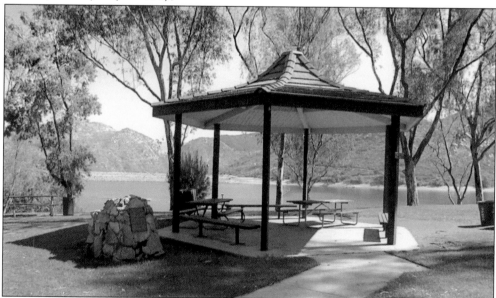

Fishing, picnicking, painting, reading, and even a little quiet reflection are all common uses for Lake Poway. In addition to gazebos, the park touts a 900-square-foot pavilion fully stocked for big events, lighted softball fields, and an archery range. (Courtesy City of Poway.)

The changing foliage at Lake Poway provides the perfect backdrop for the city's annual summer Concerts in the Park series. During the free series, live bands playing everything from rock 'n' roll and swing, to country and jazz alternate weekly outdoor performances between Lake Poway and Old Poway Parks. (Courtesy City of Poway.)

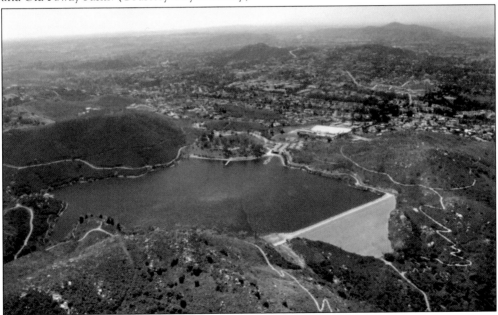

This aerial view of the man-made Lake Poway near the Green Valley area of North Poway shows off its size. One of the largest fish of its kind ever caught in Lake Poway was a 28-pound catfish snagged during a nighttime excursion. Night fishing is generally allowed at the lake during the summer months. During that time, the water is stocked biweekly with more than 700 pounds of catfish. (Courtesy City of Poway.)

SpaceDev, a company founded in 1997 on Stowe Drive in Poway's business park, propelled the city into the international spotlight when, in the fall of 2004, it provided the rocket motor used to help send a private citizen into sub-orbital space for the first time. The firm is just one of more than 460 businesses—with a combined workforce totaling more than 16,500—that call Poway's 700-acre business park home. (Courtesy *Poway News Chieftain*.)

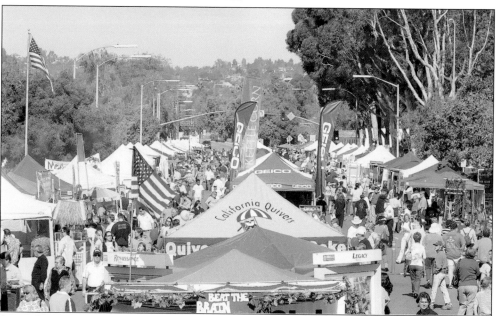

Annual street fairs are just one of the duties of the Poway Chamber of Commerce. First started as a men's social club, the chamber has grown to represent several hundred companies. In 2006, the chamber-organized Poway Business Expo netted more than $20,000. Monies raised from such events are returned to the community through scholarships and business assistance programs. (Courtesy *Poway News Chieftain*.)

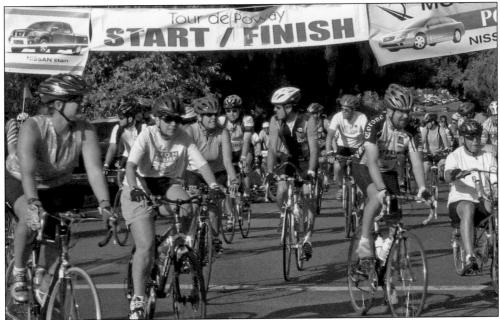

Tour de Poway, a major North San Diego County cycling event, rolls into town each fall. More than 2,000 participants from throughout the Southwest partake in the 104-, 62-, or 50-mile course that pits them against the famous Poway grade, which at points includes an eight-percent climb. (Courtesy Poway News Chieftain.)

Fenton Court, a rest spot in a local shopping center, is named after Fred Fenton, who lived from 1916 to 1992. Fenton served in the U.S. Navy from 1936 to 1957 and survived the attack on Pearl Harbor. Upon his retirement, he returned to Poway and dedicated his life to helping and honoring fellow veterans. He organized what has become an annual Memorial Day ceremony at Dearborn Memorial Park. His efforts led the U.S. House of Representatives to adopt a proclamation in his honor on December 2, 1992. (Photograph by Jessica Long.)

A one-acre park off Old Pomerado Road in southern Poway is named for Elizabeth O'Donel Bendixen, who in her later years felt so strongly about preserving Poway's rural charms that she chained herself to a tree on Carriage Road to block new road development. She lost that battle but made a lasting legacy for herself. (Photograph by Jessica Long.)

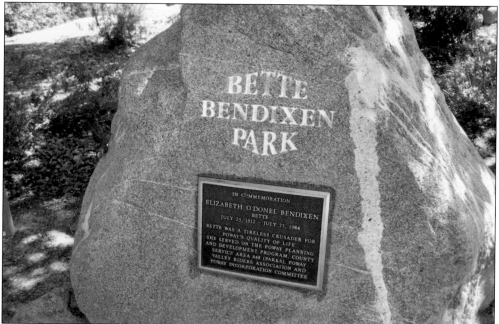

Elizabeth O'Donel Bendixen, more commonly know as "Bette," was born on July 23, 1912, and died on July 25, 1984, just two days after her 72nd birthday. She arrived in Poway in 1961 at the age of 49 and fought tooth and nail against developers who wanted to urbanize the area. (Photograph by Jessica Long.)

IN COMMEMORATION

ELIZABETH O'DONEL BENDIXEN
BETTE
JULY 23, 1912 - JULY 25, 1984

BETTE WAS A TIRELESS CRUSADER FOR
POWAY'S QUALITY OF LIFE.
SHE SERVED ON THE POWAY PLANNING
AND DEVELOPMENT PROGRAM, COUNTY
SERVICE AREA #48 (PARKS), POWAY
VALLEY RIDERS ASSOCIATION AND
POWAY INCORPORATION COMMITTEE

A plaque placed in Bette O'Donel Bendixen's memory touts her constant commitment to community service, but not just any community service. Bette's goal was to improve the quality of life in Poway for all residents through nature and open space preservations. (Photograph by Jessica Long.)

Park namesake Bette O'Donel Bendixen served on the Poway Planning and Development Program, the County Service Area No. 48 (Parks), the Poway Valley Riders Association, and the Poway Incorporation Committee, which was in charge of turning the rural county town into an active and thriving municipality. (Photograph by Jessica Long.)

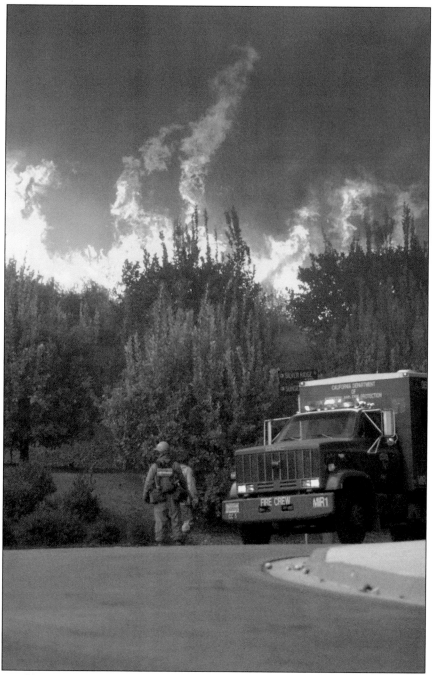

The second largest wildfire in California, the Cedar Fire, burned approximately 721,790 acres in San Diego County, including parts of eastern Poway, in late October 2003. It is second only to the Great Fire of 1889, which burned some 800,000 acres in San Diego and Orange Counties. The Cedar Fire damaged or destroyed a total of 3,640 homes, about 50 of which were in Poway. In total, 15 people were killed. None lived in Poway. Poway's neighbor to the south, the San Diego suburb known as Scripps Ranch, was not so lucky. Some 345 homes were lost there. (Courtesy *Poway News Chieftain.*)

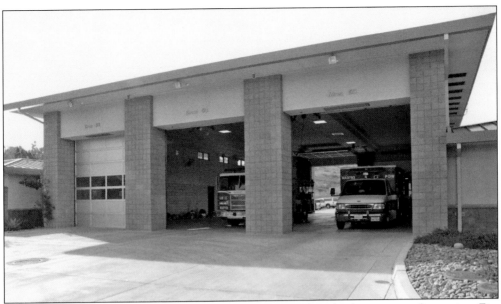

In October 2004, a year after the Cedar Fire, Poway opened its third permanent fire station, Fire Station No. 3 on Pomerado Road. The 13,600-square-foot facility was built at a cost of $3.4 million. For months while the project was being constructed, firefighters slept on-site in trailers in order to serve central Poway emergencies. The station was not constructed as a direct result of the Cedar Fire; rather, it had been in the planning stages for several years prior because of the city's growing population demands. (Courtesy *Poway News Chieftain*.)

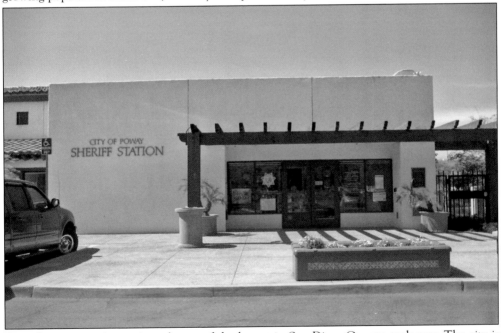

Poway's crime rate is consistently one of the lowest in San Diego County each year. The city is policed by the San Diego County Sheriffs Department through a contract arrangement. There are about 50 sworn law enforcement officers who serve Poway from the Poway Sheriffs Substation located off Poway Road near Community Park. (Photograph by Jessica Long.)

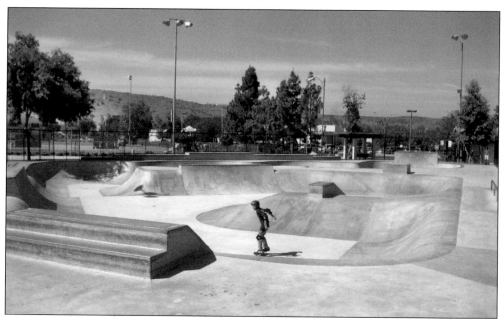

The Poway Skate Park was built to provide somewhere other than public streets, steps, and railways for young skating enthusiasts to practice and gather. With strict helmet rules in place, the park is open to all ages and is situated across the street from the Poway Sheriffs Substation and Community Park, which includes playgrounds, sports fields, a senior center, meeting rooms, and a community pool. (Photograph by Jessica Long.)

The architecture at the new Poway City Hall has been recognized and honored by several trade industry groups. Its main administration building supplies two stories' worth of office and meeting space. Glass-enclosed cases in the lobby display artifacts of the city's history. Directly east of the complex is the original Poway Fire Station No. 1. (Photograph by Jessica Long.)

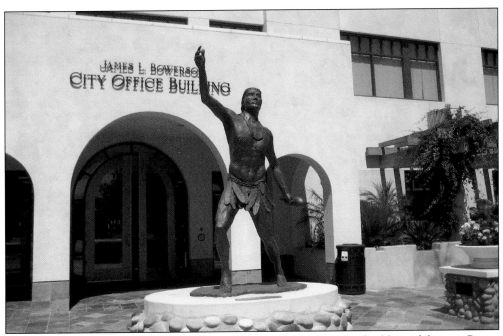

The bronze statue that welcomes visitors to the main administration building of the new Poway City Hall complex has been said to look a lot like its artist, Johnny Bear Contreras, who has served as the city's cultural liaison for his native tribe, the San Pasqual Band of Mission Indians. (Photograph by Jessica Long.)

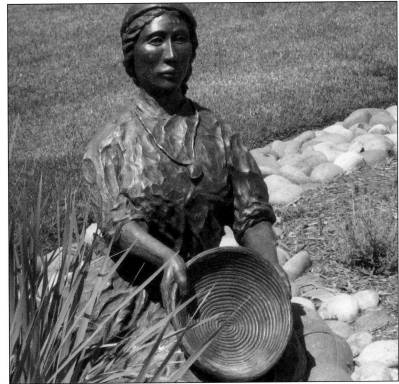

Artist Johnny Bear Contreras says the idea for *Settling Woman* came to him almost immediately. A tribute to tribal women, the statue was inspired by Contreras's own rearing. The youngest of 10 children, he drew on thoughts of his mother and sisters to make sure the statue was done in a respectful and proper way. (Photograph by Jessica Long.)

A new $20.4-million city hall complex opened in Poway in 2004. The 50,500-square-foot, two-story city administration building and the adjacent 6,000-square-foot city council chambers took more than two years to complete. The complex pays homage to Poway's past with two statues created by a local Native American artist. (Courtesy *Poway News Chieftain*.)

Officials past and present celebrated the city turning 25 in December 2005. According to local newspaper archives, Poway will be close to its build-out at about 55,000 people during the next 20 years. By 2030, the population of people over the age of 60 will nearly double from 10 to 19 percent, while people under 20 will remain constant at about 29 percent. (Courtesy *Poway News Chieftain*.)

Poway's volunteer service clubs contribute to the community with a wide variety of programs, ranging from the more light-hearted pancake breakfast that coincides with the annual Poway Heritage Day Parade, to the serious matter of helping women and children of domestic violence with new safe houses and job training. The Rotary Club of Poway is known for its annual barbecue fund-raiser at the Bernardo Winery. The Kiwanis Club of Poway, founded in 1973, is associated with Tour de Poway, the Padres Spring Training Kickoff Luncheon, and the Kiwanis Kars for Kids car show. Founded in 1944, the Poway Lions Club focuses on helping children, seniors, the physically disadvantaged, and members of the military. Since 1996, Soroptimist International of Poway works mainly with fellow Rancho Bernardo club members on a transitional housing program for women and children fleeing domestic violence. Poway is also home to the Benevolent and Protective Order of Elks Lodge No. 2543 and a VFW post. (Photograph by Jessica Long.)

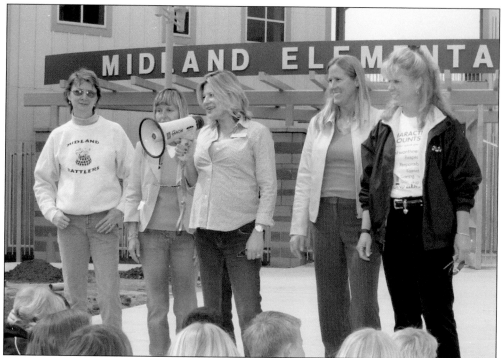

The oldest extant elementary school in Poway was rebuilt from the ground up at a cost of $18 million. The new Midland Elementary, home of the Rattlers, opened in March 2006 and was funded by a $198-million public bond measure approved by voters in 2002. The new campus was given a new mascot, Rocky the Rattlesnake, to mark the occasion. (Courtesy *Poway News Chieftain*.)

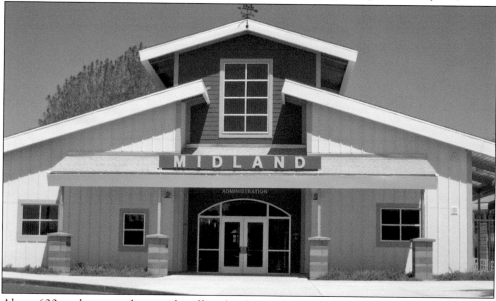

About 600 students, teachers, and staff work, play, and learn at Midland Elementary each year. In order to help students feel like a part of the new Midland, school administrators asked them to pick a new mascot and a correlating name for it. Prior Midland mascots have included the Dragons and the Warm Fuzzies. (Photograph by Jessica Long.)

Six

POWAY PRESERVED

Poway has made great strides to become a modern city thriving with state-of-the-art technologies and opportunities. But it is also a city that has taken great lengths to remember the past and preserve the stories of early settlers for future generations. More than just old photographs tell tales. Preservers of Poway's history also like to organize hands-on, interactive events designed to visually take residents back to their early counterparts to experience what life was like then. These events include such characters as mountain men and women, cowboys and cowgirls, buckaroos and gunslingers, train robbers and lawmen, soldiers and nurses. One area of town devoted specifically to this point is Old Poway. Located on the east side, more or less in the middle of everywhere, Old Poway includes a park that is the site of museums, shops, and restaurants. On the south side of town, the Kumeyaay-Ipai Interpretive Center is designed to preserve the Native American roots of Poway, with more hands-on glimpses into the lives of the earliest residents.

Currently, the city is working on ways to expand its homage to the past even further with possible additions to Old Poway such as a fine arts center perfect for showcasing local artists. Though perhaps less obvious than the Old Poway area and the interpretive center, many more tidbits and clues to Poway's past are scattered around town. These would include the statues at city hall, the streets named after early settlers, and even the area's intention to attract a British railroad company.

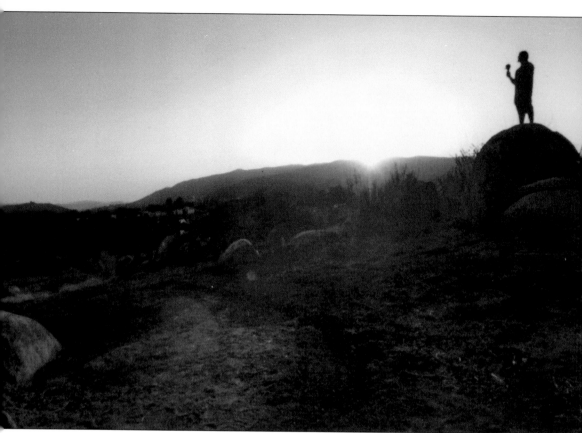

A Kumeyaay Indian says a prayer at sundown. Powegians are very proud of their heritage. A statue created by local Native American artist Johnny Bear Contreras that mimics this position now welcomes visitors to the new Poway City Hall complex. The bronze statue is titled *Seeing*. A statue depicting a woman preparing food for her family, entitled *Settling Woman*, can be found in the complex's adjacent courtyard. A dedication plaque placed next to the woman reads, " 'Emat Kuuyum—Headed Toward Earth." A rock riverbed surrounds the woman to represent water, which was the basis of life for the Kumeyaays, according to the plaque. The sign goes on to state, "An oak tree, commonly found in the Poway landscape, provides welcome shade on a warm day and acorns for grinding." (Courtesy City of Poway.)

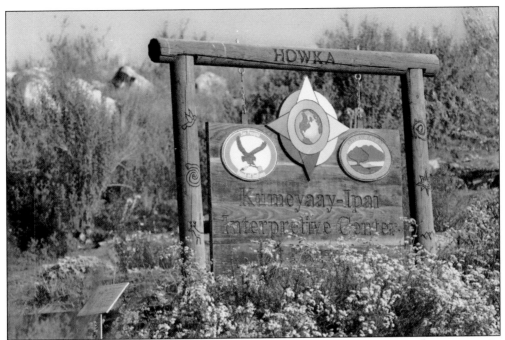

The Kumeyaay-Ipai Interpretive Center is a popular field trip for Poway students consisting of a five-acre site rich in Native American history. The city started acquiring the various parcels that comprise the center in 1987. Docents offer regular interpretive tours to educate the public in the heritage practices of the ancient Kumeyaays. (Courtesy City of Poway.)

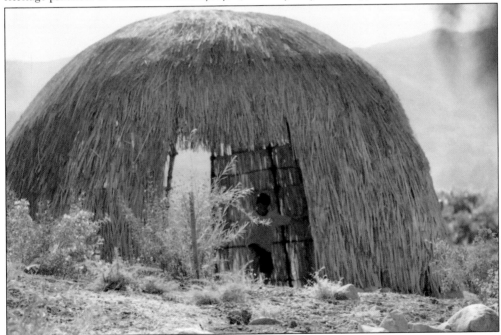

A Kumeyaay-Ipai Indian hut is pictured here. Poway has made a strong effort to maintain its Native American heritage, going so far as to re-create a Kumeyaay-Ipai village as it would have looked long before white settlers—or even the Spanish—came to the area. (Courtesy City of Poway.)

An old water tower, symbolic of Poway in the 1800s and early 1900s, was moved to Old Poway Park, which sits on a four-and-three-quarter-acre site. In addition to the water tower, two historically significant structures were transported there and restored: Poway's first public assembly building, the International Order of Good Templars Hall; and the Nelson House. (Courtesy City of Poway.)

Although it is not quite the farmland it once was, the city of Poway does still include images of the past spread throughout town—images like that of an old farm barn and the tools of the trade. (Courtesy City of Poway.)

Just south of Old Poway Park is Old Poway Village. The small shopping center houses a slew of small mom-and-pop-type businesses, from an ice cream shop and scrap-booking store, to a child's clothing boutique and hair salon. The center's architecture was recently updated to match the old-fashioned charm of Old Poway Park. (Photograph by Jessica Long.)

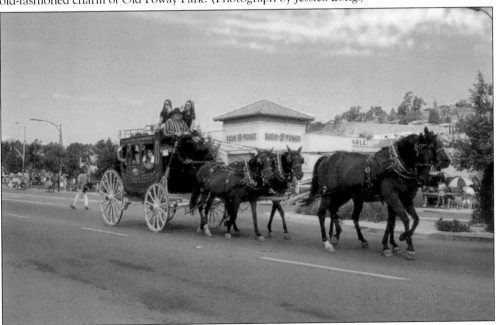

The need for regular stagecoaches in and out of town may be long gone, but a Wells Fargo stagecoach still manages to make an appearance in Poway for the city's annual parade. The Poway Heritage Day Parade is part of Poway Days, a couple of weeks of celebrations intended to welcome to town the annual Poway Rodeo. (Courtesy City of Poway.)

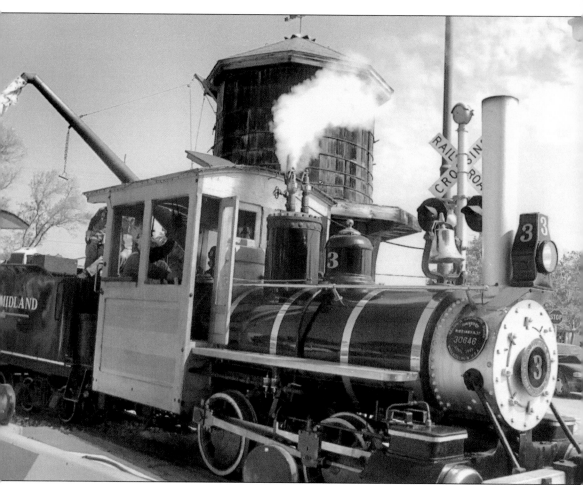

Trains are not the only things intended to give Old Poway Park its old-fashioned charm. Overshiner's Blacksmith and a gazebo were built there to enhance the ambiance. The park also includes the Porter House, the Poway Historical and Memorial Society Museum, and the Hamburger Factory, a popular local eatery off the beaten path that is family-owned and serves simple American burgers and fries. The place is covered in memorabilia from Coca-Cola signs, to outdated farming tools. Old Poway Park also serves as the spot for a regular farmers' market—a reminder of the days when Poway farmers and ranchers would carry their goods, be it fruit or vegetables, to "local" markets in downtown San Diego. Early settlers in the farming and ranching business lucky enough to have less-perishable goods could take advantage of San Diego's port system and ship goods to other regions. (Courtesy City of Poway.)

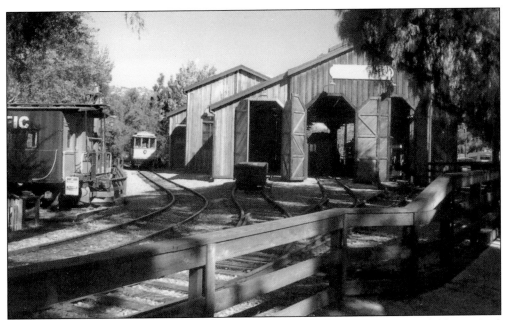

The train barn at Old Poway Park was built in modern days to house a 1907 Baldwin No. 3 steam engine, a 1938 Fairmont Speeder and ore cars, an 1894 Los Angeles yellow trolley, and a San Francisco cable car. The barn has already undergone its first major face-lift to catch up to current times, even though it was originally constructed less than 20 years ago. (Courtesy City of Poway.)

Old Poway Park, located off Midland Road, is one big tribute to the past. Efforts continue to be made to expand the area with the hopes for an art center and more dining and shopping opportunities. The park currently consists of several old structures, trains, a museum, and, of course, open space ideal for a small quiet picnic. (Photograph by Jessica Long.)

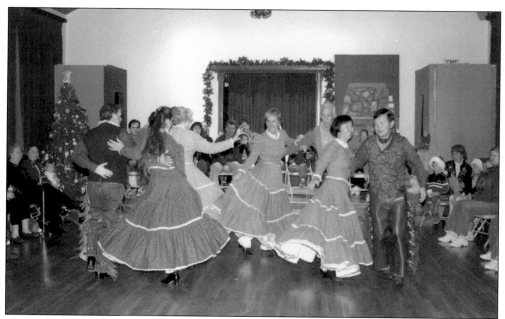

Like the days of old when townsfolk gathered for social events at the International Order of Good Templars Hall, current Poway residents use the hall for such things as square dancing and the occasional political debate. (Courtesy City of Poway.)

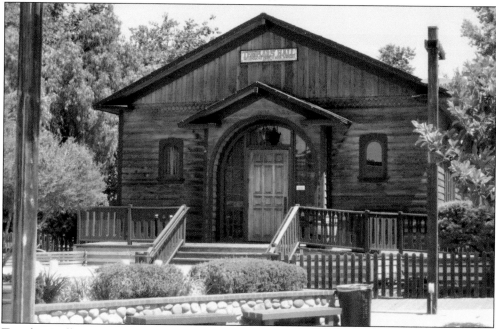

Templars Hall, as it is commonly known, was built on Midland Road in 1886 to serve as a meeting place. In 1942, the hall was purchased, remodeled, and moved by the Christian Science Society. Today it has been restored to its original purpose as a community meeting place, but through the years, it has also been used as a church-run thrift store and a tack and feed store. Sometime after 1980, the City of Poway bought the property and moved it to its current location. (Photograph by Jessica Long.)

Christmas in the Park, a traditional event at Old Poway Park, features carolers. But the park is also good for year-round picnicking. Its two acres were styled after the Teddy Roosevelt National Park System with lots of trees and winding paths. The Poway Historical Society also runs several museum exhibits at once, from early wedding dresses to World War II memories. In recent years, the society has gone through painstaking efforts to re-create a Poway classroom of the early 20th century. A simple wooden desk, blackboard, geography maps, oil lanterns, tough lesson plans, and a water basin complete the scene. Visitors learn that, in the past, schoolchildren had to take turns bringing water to class so that everyone could wash up. (Courtesy City of Poway.)

The Nelson House, relocated and restored in Old Poway Park, was dedicated in 1994 with approximately 5,000 people stepping in to take a tour that weekend. The patent for the homestead was obtained by Niles Nelson on June 27, 1883. The home as it looks today, however, is not the original homestead of the late 1880s; rather, it is a Nelson family homestead built in the early part of the 20th century. (Photograph by Jessica Long.)

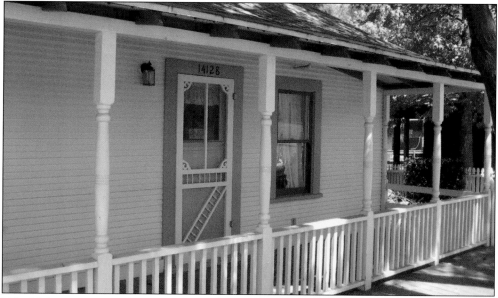

Niles Nelson once served as a trustee on the Poway School Board and died in 1921. In 1925, his wife, Helena, settled his estate by willing the Nelson family farm to the couple's three children: Albert J., Oscar, and Ida. The family sold the farm to H. W. Frame of Poway Ranch in 1930. The Frames lived there through 1956 and then made it a rental property for a few years until it was again purchased. The property would change hands several more times before the city bought it in 1991. (Photograph by Jessica Long.)

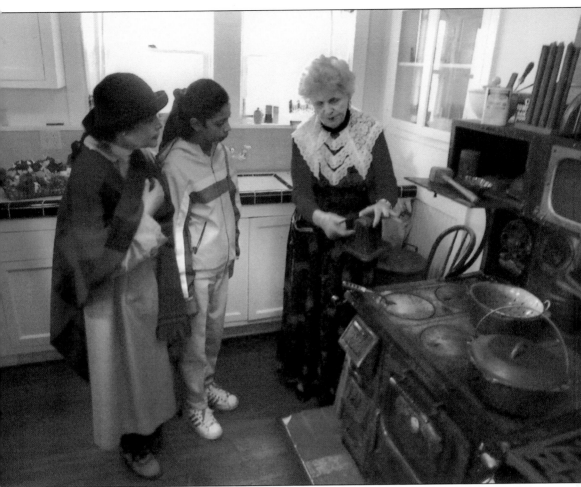

Docents at the Nelson House in Old Poway Park are frequently on hand to demonstrate such things as cooking techniques from the past to the students of today. The school year is not the only time for field trips to the Nelson House, however. During the summer, classes are often held there for residents of all ages to learn a variety of old-fashioned skills. The Nelson House is frequently open for big community events in which residents are encouraged to come watch reenactments, demonstrations, and other related features designed to teach them about history. Interesting items found today in the Nelson House include a kitchen with a wood-burning stove, a washtub and washboard, a glass butter churn, a kerosene lamp, a Victrola music box, homemade quilts and bedspreads typical of the old days, a pitcher and bowl for daily washing, and a claw-foot bathtub. (Courtesy City of Poway.)

The Nelson House is managed by the Poway Historical Society and a local garden club, which maintains a small garden along the house's southern edge. (Photograph by Jessica Long.)

The Porter House, restored and preserved in Old Poway Park, was once the residence of Col. John and Helen Porter. A dedication on December 2, 1997, deemed the old home and business the foundation of Old Poway Park. (Photograph by Jessica Long.)

In Memory of

**Colonel John
and
Mrs. Helen Porter**

whose home and business are the
foundation of Old Poway Park

Dedicated December 2, 1997

Col. John Porter had envisioned a railroad through his property more than 100 years ago, but the plans never materialized. Porter wanted the Rattlesnake Creek Railroad to wrap around his property, which was also home to a shopping area of the time. He envisioned using the train as commercial entertainment rather than just a means of transportation. His dream lives today in Old Poway Park. (Photograph by Jessica Long.)

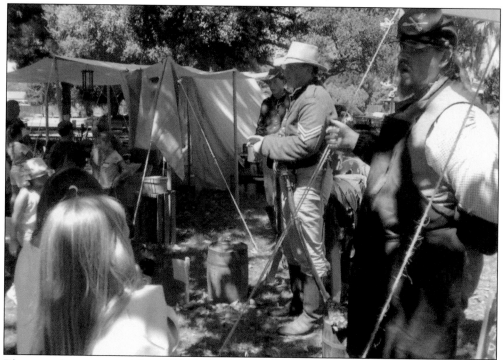

The past often comes to life in Old Poway Park for such annual events as Rendezvous in Poway. During the event, which is sponsored by the city and the Old Poway Park Action Committee, living history tents are set up in the park to give residents a glimpse into what life was like through such eras as the Civil War. (Courtesy City of Poway.)

Events designed to teach current residents about the past sometimes feature mock gunfights. The gunfights center around a train robber and use Old Poway Park's old-fashioned train setup. The good guys usually win, much to the crowd's delight. (Courtesy *Poway News Chieftain*.)

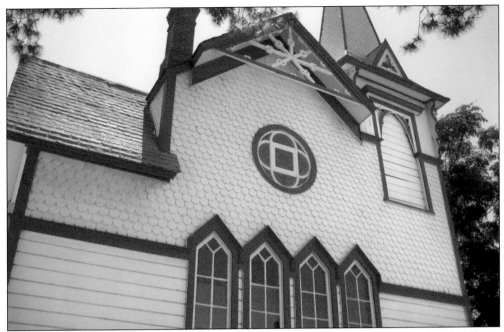

The Community Church of Poway, located on the corner of Community Road and Hilleary Place, is the oldest wooden structure of continuous use as a church in San Diego County. Though originally founded in 1883 by the Methodist Episcopal Church, today it serves the United Church of Christ. (Photograph by Jessica Long.)

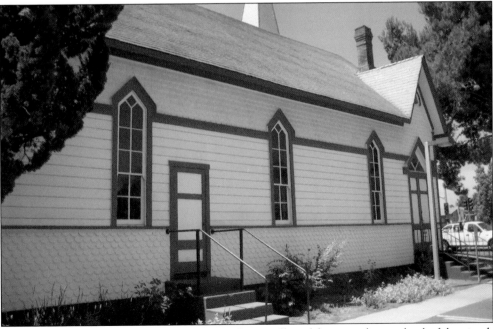

The actual Community Church structure, with its scalloped fringe and several colorful stained-glass windows, was not completed until the late 1880s. It has changed hands among several denominations over time, starting with an exchange by the original founders with the Oceanside Congregational Church in 1893. (Photograph by Jessica Long.)

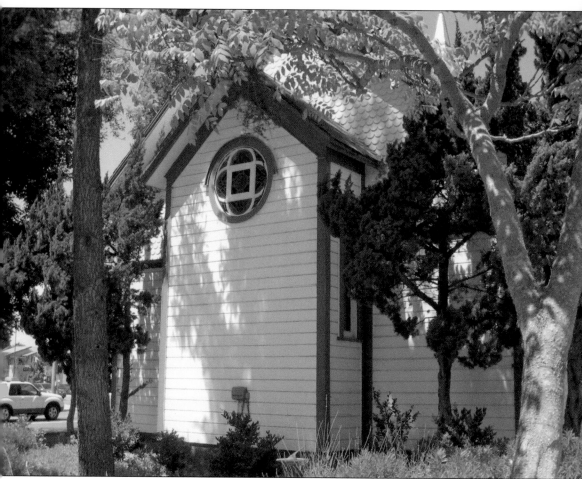

The Community Church of Poway now hosts wedding and memorial services in addition to the Sunday worships led by Rev. Glen Larson. Visitors are likely to notice a few religious symbols spread throughout both the exterior and the interior. Those symbols include an alpha and omega design embedded in a circular stained-glass window above the pulpit. Christian symbols, the alpha and omega, represent the eternal nature of Jesus Christ and are the first and last letters of the Greek alphabet. The Community Church is one of several active churches representing various denominations in the city today. Another notable one in Poway's history is the Christian Science Pavilion, which was featured in the 1964 New York World's Fair. It was shipped more than 4,500 miles via the Panama Canal to Poway in 1965 to become a building for the First Church of Christ, Scientist on Pomerado Road. (Photograph by Jessica Long.)

SELECTED BIBLIOGRAPHY

Hassan, Louhelen Elizabeth. *Paguay*. Poway, CA: Poway Historical and Memorial
 Society, 1993.
Poway: A Pictorial History. Poway, CA: Poway Historical Society, 1995. (Reprint of
 volume originally published by the Palomar Savings and Loan Association, 1981.)
Pruninskas, Kay. *The Early Years*. Poway, CA: Poway Historical and Memorial Society, 1997.
van Dam, Mary Augusta. *As I Remember Poway, Memoirs of Mary van Dam*. Poway, CA:
 Poway Historical Society, 1985.
www.ci.poway.ca.us
www.mylocalnews.com
www.poway.com
www.powayhistoricalsociety.org
www.powayunified.com
www.pph.org

DISCOVER THOUSANDS OF LOCAL HISTORY BOOKS
FEATURING MILLIONS OF VINTAGE IMAGES

Arcadia Publishing, the leading local history publisher in the United States, is committed to making history accessible and meaningful through publishing books that celebrate and preserve the heritage of America's people and places.

Find more books like this at
www.arcadiapublishing.com

Search for your hometown history, your old stomping grounds, and even your favorite sports team.

Consistent with our mission to preserve history on a local level, this book was printed in South Carolina on American-made paper and manufactured entirely in the United States. Products carrying the accredited Forest Stewardship Council (FSC) label are printed on 100 percent FSC-certified paper.

MADE IN THE

USA